Brad Finger

Jan Vermeer

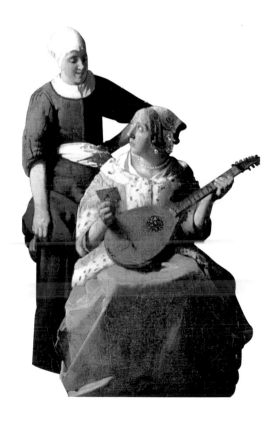

Prestel

Munich · Berlin · London · New York

Context

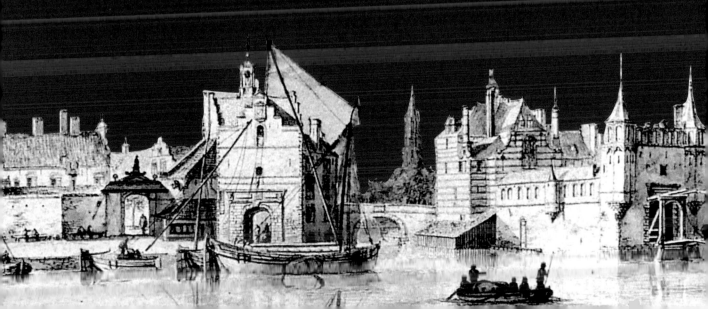

"It is a most sweet town, with bridges and a river in every street."

Samuel Pepys, writing of Delft in his Diary on 18 May 1660

The Golden Age of Delft ...

... occurred during the 17th century. The Dutch Republic won full independence from Spain and established itself as the leading economic power in Europe. The wealth that flooded into Delft and other Dutch cities led to a flouri-shing of art, literature, philosophy, and science. This age saw the unprecedented growth of the middle class, which achieved an influence in Dutch society that it had never attained before.

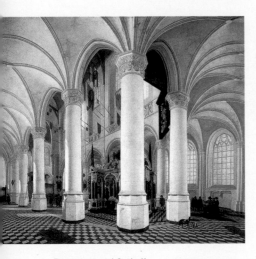

Protestant and Catholic spaces of the Golden Age: the grand protestant Nieuwe Kerk in Delft (left) contrasts with the small Catholic attic chapel of the Amstelkring in Amsterdam (right).

William the Silent

William I of Orange, also known as William the Silent, was a nobleman who spearheaded the fight for Dutch independence in the late 1500s. During the war, William set up his capital at Delft, where he was assassinated in 1584. William's beautiful tomb was constructed in Delft's Nieuwe Kerk, or New Church. The tomb became one of the most important places of pilgrimage in the newly independent Dutch Republic.

During the 1600s ...

→ ... the cities of Haarlem, Delft, Amsterdam and Dordrecht grew in size, wealth and importance.

→ ... fires ravaged many cities in the Netherlands, and large parts of Delft burned down in 1636. Yet Delft emerged from this tragedy even stronger than before. Vermeer, who was born only four years before the fire, began his remarkable career as a painter in 1653.

The Porcelain Capital of Europe

Dutch trade with China exploded during the 1600s, and the techniques of Chinese tin-glazed porcelain makers were studied by craftsmen in Delft. These craftsmen soon produced some of the most desirable porcelain in Europe. Delft porcelain, also known as Delftware, remains a cultural symbol of the city today. Blue – and – white Delftware tiles often appear in the works of Vermeer and other Dutch painters.

A Philosophical People

The Dutch Golden Age produced many important philosophers. The most famous of these thinkers, Baruch Spinoza (1632–1677), came from a Portuguese Jewish family. Spinoza's political beliefs included a strong support for religious freedom, an attitude shared by many liberal people in Dutch society. Jews and other ethnic minorities found a haven in the Netherlands during the 1600s.

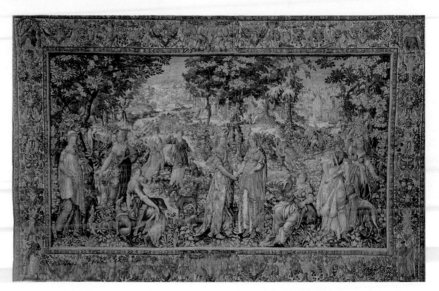

Delft Tapestries

Vermeer's canvases also display another famous product of 17th-century Delft—its tapestries. These beautiful works of woven art depicted everything from landscapes to naval battles, and they were exported throughout Europe.

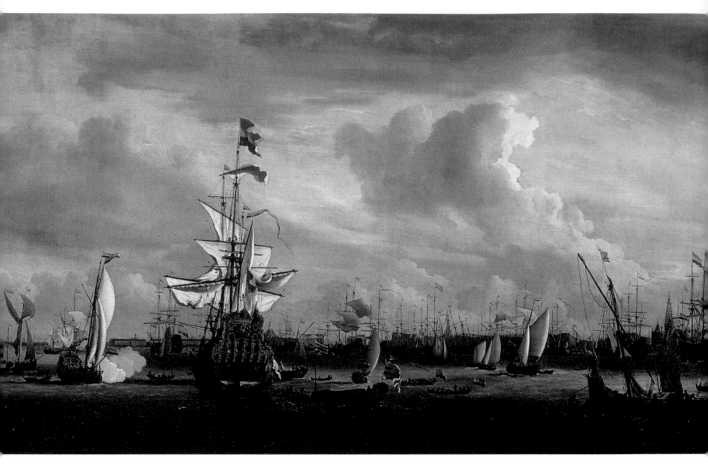

The busy harbor of Amsterdam. The Dutch
Republic relied on its powerful sea fleets to defend
its borders and promote international trade.

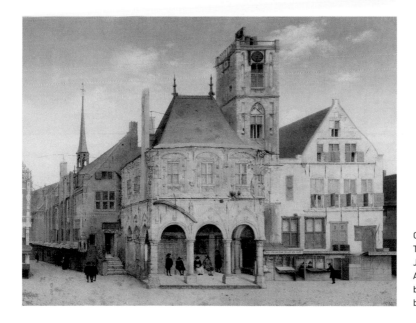

Center of commerce. This painting by Pieter Jansz. Saenredam depicts Amsterdam's old town hall before it was destroyed by fire in 1652.

The Dutch Republic

"All in general striving to adorn their houses, especially the outer or street room, with costly (art) pieces ... yea many times blacksmiths, cobblers, etc. ... will have some picture or another by their forge and in their stall."

A description of art patrons in Amsterdam
by English traveler Peter Mundy, c. 1640

Freedom in the Netherlands

Vermeer lived in a country that had undergone a great revolution. During the early 1500s, when Spain ruled the Dutch provinces, the Reformation spread throughout Dutch cities. By the time Philip II (1527–1598) inherited the Spanish empire in 1556, the Protestant faith had replaced Catholicism in much of what is now the Netherlands. Radical Protestants took over churches in Delft and other Dutch cities, destroying Catholic images and provoking Philip, a devout Catholic. The King responded by sending armies under his general, the Duke of Alba (c. 1508–c. 1582), and quashed the rebellion. Spain then used the Inquisition to root out and punish many Protestant leaders.

Jacob van Ruisdael's grand view of Haarlem and the surrounding countryside: Ruisdael and other 17th-century Dutch painters helped develop the art of the landscape.

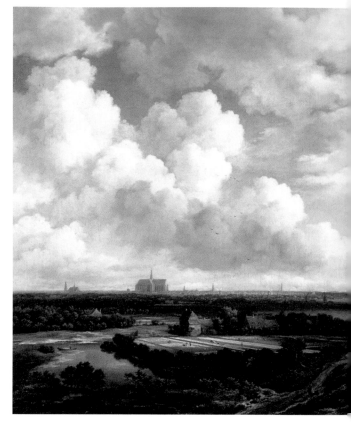

The harsh measures imposed by Philip only strengthened the will of the Dutch to establish their own country and their own faith. Under the leadership of William the Silent, the Netherlands began a long war of independence from Spain. This war was largely won by 1581. But fighting with Spain would continue until 1648, when Spain formally recognized the Dutch state.

An Empire of Trade

In the 17th century, the young Dutch Republic emerged as a leading political and economic power, using its strong sea fleets to defend its borders, promote international trade, and develop an empire in the New World. Powerful trading companies, such as the Dutch East India Company, helped establish Dutch colonies in western Africa, southeastern Asia, and North and South America. The most famous Dutch colonial city, New Amsterdam, later became New York City.

Goods from all over the world flooded into Dutch ports. Exotic spices came from the West Indies, fine porcelain arrived from China, and oriental textiles poured in from the Muslim Ottoman Empire. Dutch traders also helped pioneer the use of modern stocks and bonds, and the Amsterdam stock exchange became the most powerful in the world.

Religion and Continued Conflict

The internationally oriented economy of the Netherlands helped make it a cosmopolitan society. Toler-

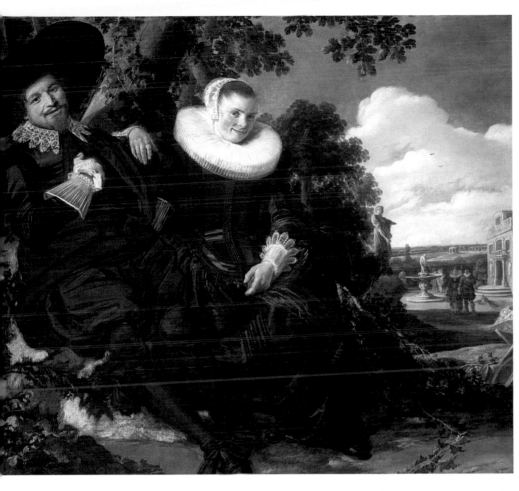

Franz Hals' *Married Couple in a Garden*: many artists of the Golden Age brought a new informality to portrait paintings.

ant Dutch cities accepted Jews, Huguenot Protestants, and other religious minorities from countries that had persecuted them.

However, the great wealth and tiny size of the Netherlands left it vulnerable to attack from other countries for much of the 17th century. Wars with England in the 1650s and 1660s were followed by the "Great War," in which the Republic had to defend itself against both England and France (1672–1678). The last conflict proved particularly damaging to the young country, which had to temporarily flood much of its countryside in order to protect the territory from ground attacks. This desperate measure involved opening up canals that had been built to reclaim arable land that lay below sea level. Though the Dutch ultimately preserved their independence, the war caused great economic hardship and partially destroyed the country's lucrative art market.

Art for the Common Man

For most of the 1600s, economic wealth and cultural diversity stimulated Dutch artists. Before this time, fine art in Europe had been reserved for religious institutions or for royalty and other members of the aristocracy. But the Netherlands did much to change the definition of the art patron. The growing Dutch middle class had now become wealthy enough to support an art market of their own. Bakers, masons, stockbrokers, and other professional people began purchasing more and more art for their homes. This change in the demographics of art patronage

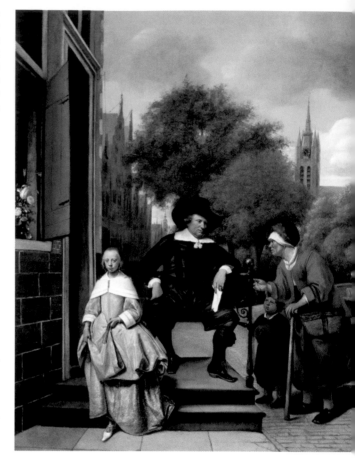

Art patrons of the young Dutch Republic were often prominent local townspeople, such as the man in Jan Steen's *The Burgomaster of Delft and His Daughter*. This painting highlights the wealth of the burgher and his daughter by contrasting the elegance of their dress with the humble clothes of the old woman and boy.

also meant a change in the subject matter of art, especially in painting. Dutch painters turned away from such traditional subjects as classical mythology and Christian iconography, and they began depicting secular themes. The Dutch greatly advanced the art of painting landscapes and architecture. Other artists produced portraits of leading middle-class families, as well as intimate domestic scenes. Objects of daily life—including silverware, fruit, and textiles—appeared more and more often in Dutch art, and with increasingly minute accuracy. Painters often used individual objects to symbolize abstract concepts. Roses, for example, could represent love or purity.

The Art Dealer

New art forms and art patrons led to the growth of professional art markets. Art dealers proliferated as never before throughout the Netherlands, and art guilds often accepted dealers as members. Both Vermeer and Vermeer's father relied on the selling and trading of paintings as an important source of income.

From Conservative Capital to Artistic Hub

Throughout much of the 17th century, Amsterdam was the center of progressive Dutch art. Many leading painters of this age, including Rembrandt Harmenszoon van Rijn (1606–1669) and Jacob Isaakszoon van Ruisdael (1628–1682), did much of their best work in Amsterdam. Other Dutch towns also inspired great artists. Frans Hals (c. 1582–1666) and Jan Steen (c. 1626–1679) worked mostly in Haarlem. Delft, however, remained an artistically conservative city for the first half of the century.

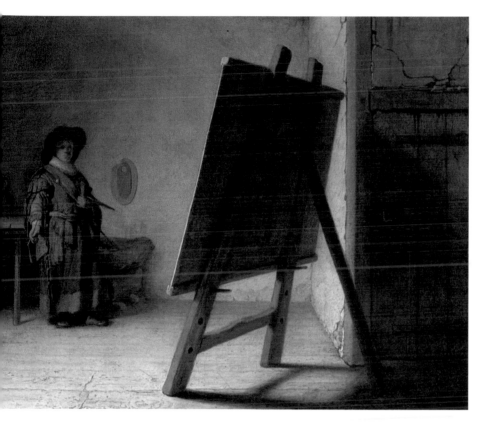

Artists themselves became important subjects of 17th-century Dutch painting, as in Rembrandt van Rijn's portrayal of a painter in his studio.

Delft's culturally staid reputation attracted few artists in the vanguard. Many historians attribute this unprogressive attitude to the city's close ties with William the Silent and the House of Orange-Nassau. Princes of this noble family had long served as stadtholders, or governors, of the Netherlands.

In 1650, however, William II of Orange threw his family into disarray when he died unexpectedly of smallpox. Amsterdam, which had opposed many of the stadtholder's policies over the years, took the opportunity to establish more political control throughout the country. This shift in political power also marked an important change in the artistic cli-mate of Delft. With Delft now more closely tied to Amsterdam, many talented painters from that larger city decided to move to Delft. Such artists included Pieter de Hooch (1629–1683) and Carel Fabritius (1622–1654), and they breathed new life into Delft's cultural milieu. Fortunately for Jan Vermeer, the artistic transformation of Delft occurred just as he was coming to maturity as an artist.

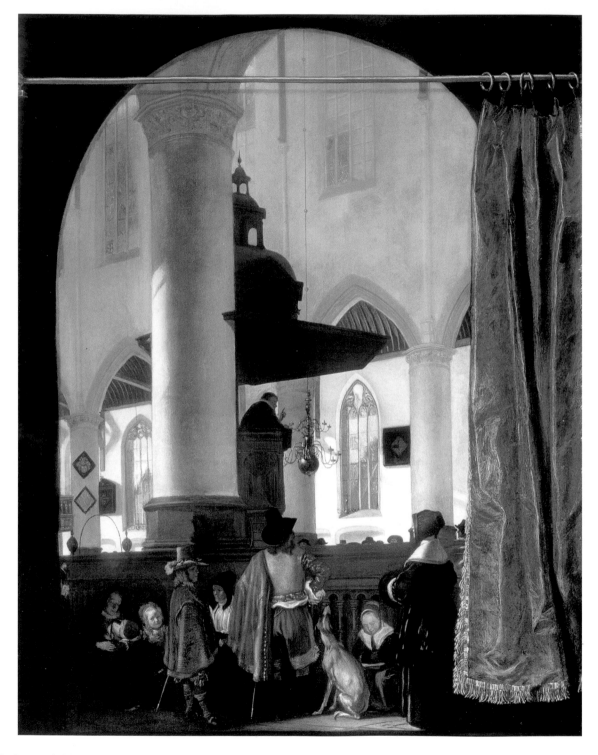

Intimate faith Around 1650, architectural painters in Delft began portraying church interiors in ways that resembled paintings of private homes. With its drawn curtain, Emanuel de Witte's image of the Oude Kerk in Delft has the intimacy of a scene from a domestic chamber.

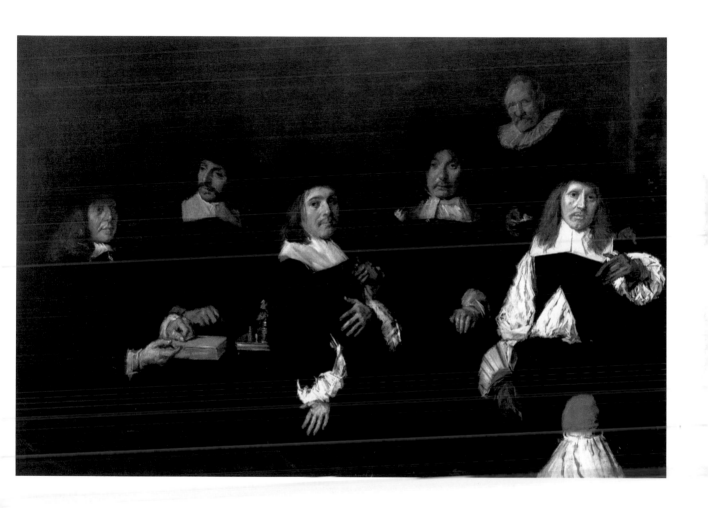

Sense of community Group portraits became common in 17th-century Dutch society, and they helped reinforce community spirit in Dutch cities. Frans Hals' portrait of the regents of Haarlem's old men's almshouse features penetrating character studies.

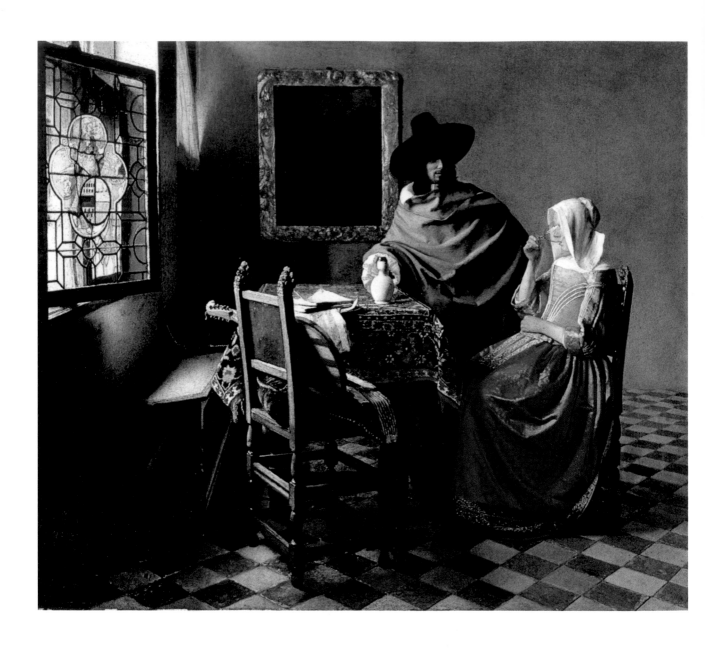

The Glass of Wine Painted relatively early in his career, from about 1658–1560, this image represents one of Vermeer's most richly detailed works. The warm colors of the floor tiles and elaborate stained glass window give the scene an inviting quality.

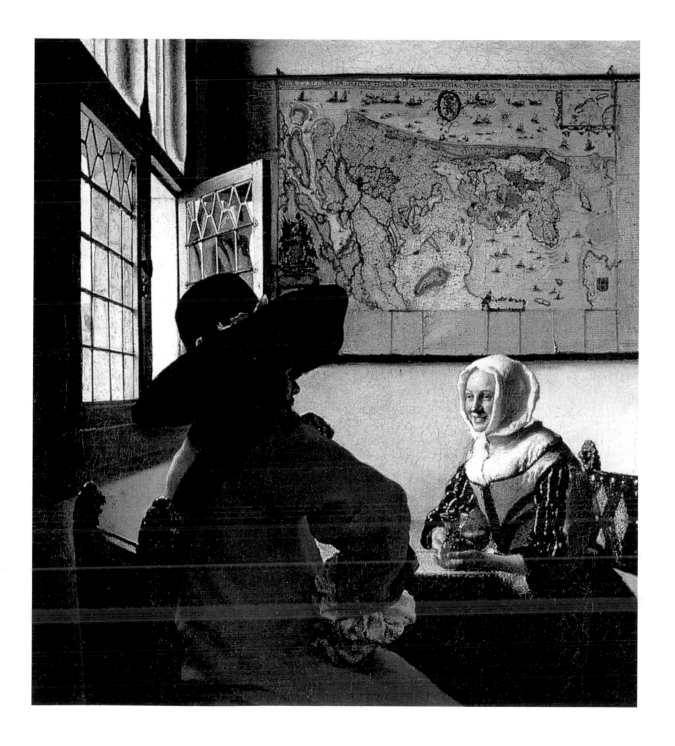

A modest maid In Vermeer's *Soldier and a Laughing Girl*, the girl's "laugh" seems rather restrained and slightly self-conscious. Unlike such artists as Jan Steen or Frans Hals, Vermeer rarely allowed his figures to express their emotions in immodest ways. He preferred quiet contemplation to boisterous energy.

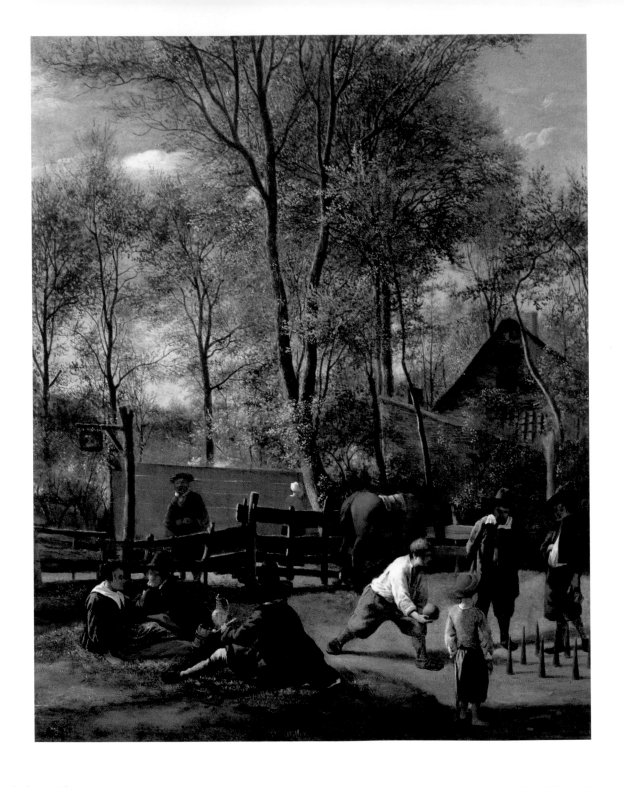

Leisure time Dutch painters were among the first to capture images of ordinary men and women doing ordinary activities. This work by Jan Steen depicts a lazy afternoon scene of picnickers and children playing Dutch pins, an early type of bowling or skittles.

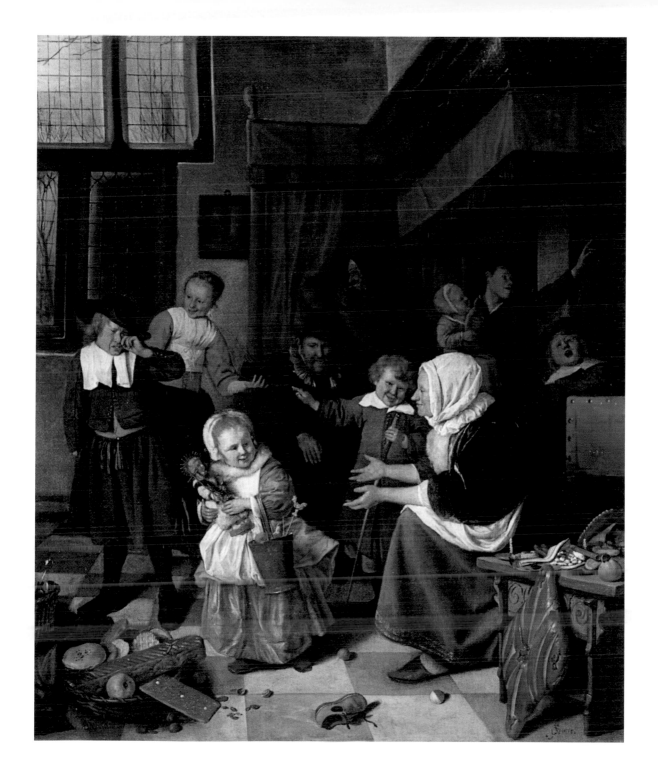

Lively households Jan Steen also specialized in portraying the chaotic nature of family life in the Netherlands. Dutch households often included many generations, and—as today—the adults often had a difficult time making their unruly children behave properly.

Fame

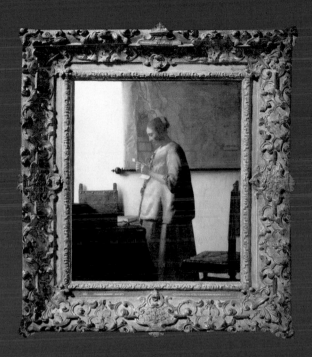

"To see one picture by van der Meer [Vermeer], I traveled hundreds of miles: to obtain a photograph of another van der Meer, I was madly extravagant."

19th-century art critic
Étienne-Joseph Théophile Thoré

Local renown ...

... was about all that Vermeer achieved during his lifetime. Yet the painter was lucky enough to live in one of the most vibrant, culturally innovative societies of the 17th century. The business of art flourished in Dutch cities as it never had before. Many foreign writers, artists, and art connoisseurs traveled to the Netherlands to witness an art culture unique in Europe at that time. A few of these people even visited Vermeer.

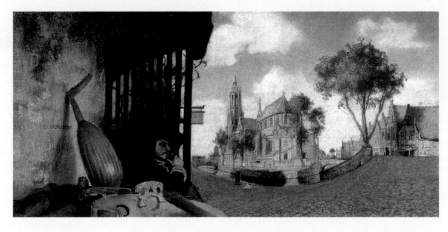

Carel Fabritius' mysterious view of Delft remains one of the most intriguing portraits of the city.

The Business of Painting

Dutch artists not only produced great art, they also played an important role in developing art as a lucrative industry. Long before the multi-million dollar auctions of recent years, many 17th-century Dutch painters were obtaining sizable prices for their works. Certain painters commanded higher prices than others. One, Gerard Dou (1613–1675), could obtain 1,000 guilders for a single work. By contrast, Vermeer's paintings probably sold for about a tenth of that amount.

During Vermeer's lifetime ...

-→ ... the painter was twice elected an officer of the town's artist guild, the Guild of St. Luke. Each term of office lasted two years.

-→ ... the growth of the international art market helped advance the practice of art authentication. Vermeer himself served as an authenticator of Italian paintings for a wealthy German client.

-→ ... more artists began traveling and living abroad.

The Great Master

Some Dutch artists developed influential schools of painting. Rembrandt van Rijn mentored a number of famous artists, including Vermeer's acquaintance Carel Fabritius. Through his students, Rembrandt's fame spread across the Netherlands and into other countries. By contrast, Vermeer's tiny studio exerted little influence on other artists during his lifetime.

Market Square

Much of Delft's commercial life took place on the city's beautiful market square. This square was dominated by an impressive city hall. Internationally admired even in the 17th century, Delft's market square played an important role in the history of Vermeer's family. Vermeer's father ran an inn and an art dealing business on the square, in a building called the *Mechelen*.

Travelers to Delft

Samuel Pepys (1633–1703), the famous English diarist, visited Delft and praised some of the art he found there. After observing a sculpted sea fight on an elaborate Delft tomb, Pepys called it "the best cut in marble, with the smoke the best expressed that I have ever seen in my life." Vermeer also received attention from important international dignitaries, including the French diplomat and art patron Balthasar de Monconys.

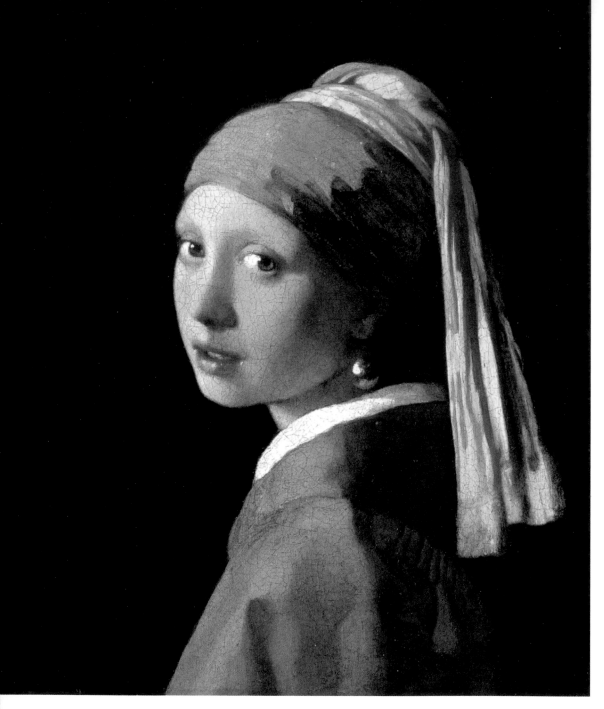

Vermeer's best-known painting, *Girl with a Pearl Earring*, portrays its subject in a strikingly frank and direct manner. Yet Vermeer's impressive images probably received little attention outside of Delft during his lifetime.

Much of the beauty in Vermeer's work lies in the details. In *Girl with a Pearl Earring*, the artist uses sensitive color and subtle modeling to give the girl's skin a creamy, lustrous texture. Delicate pools of light enliven the irises, lips and earring.

"A Masterful Artist"

"In Delft I saw the painter Vermeer who did not have any of his works: but we did see one at a baker's, for which six hundred livres had been paid, although it contained but a single figure, for which six pistoles would have been too high a price."

Balthasar de Monconys

An Obscure Life

Vermeer, like most people of his day, lived and worked in a relatively small community and didn't venture far from the confines of his hometown. Thus the kind of worldwide fame that a great artist enjoys today was unavailable to Vermeer in his lifetime. Yet Jan was not a hermit, either, and he seems to have become a relatively prominent man in Delft.

Vermeer's good standing in Delft is evident from his earliest recorded transactions as an adult. Shortly after his wedding in 1653, Jan's name was recorded at a notary's office in the company of the well-known artist Gerard ter Borch (1617–1681). Vermeer's acquaintance with this successful painter indicates that the young Jan could already claim a number of important contacts in Delft's art community.

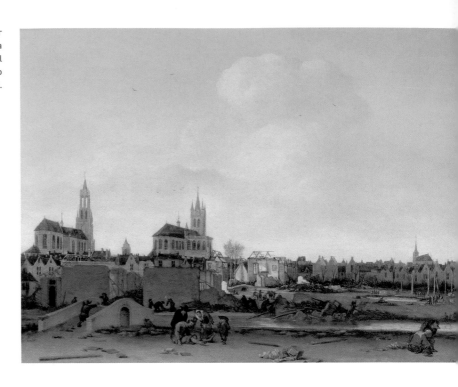

The explosion of a gunpowder magazine in 1654 destroyed a large section of Delft. Carel Fabritius was one of many who died in this catastrophic event.

At the age of thirty, in 1662, Vermeer was elected an officer of the Guild of St. Luke. He became the youngest man in decades to acquire this honor. Jan had produced some of his finest works by this time, and he clearly had earned the admiration of his professional peers.

Vermeer and the Artists of Delft

Jan's fellow painters in Delft included some who would become almost as famous as Vermeer. One such artist was Carel Fabritius. Fabritius began his career as pupil of Rembrandt van Rijn, and he moved to Delft around 1650. The style of Fabritius, which combined penetrating character studies with a certain mysterious atmosphere, can be seen reflected in a number of Vermeer's paintings.

In 1654, Fabritius died in one of Delft's worst disasters. The city had been a storage place for gunpowder and arms since the time of William the Silent. But on 12 October, 1854, one of the gunpowder magazines exploded, destroying a large section of the town. Fabritius was among the numerous Delft residents who perished in the rubble. Many painters and artists would memorialize this event over the subsequent years. Fabritius was eulogized by Arnold Bon in a poem published in 1667. This poem also praised Vermeer and recognized his contributions to Delft's artistic community. The work's last lines read:

Thus did this Pheonix, to our loss expire,
In the midst, and at the height of his career,
But fortunately there arose from the fire
Vermeer, who masterfully trod his path.

A Self-Portrait?

Some art critics consider the figure on the left-hand side of Vermeer's *The Procuress* (pages 27, 30) to be the artist himself. Like many self-portraits of the period, the man stares directly at the viewer and adopts a rather provocative expression. Yet we may never know for certain the true identification of this figure, or the true appearance of Vermeer.

No undisputed portraits of Vermeer have survived. However, some scholars believe that this smiling figure from Vermeer's own *The Procuress* (page 30) may be a self-portrait.

Wider Recognition

Tantalizing pieces of the historical record indicate that Vermeer may have achieved fame outside of Delft. The French diplomat Balthasar de Montconys (1611–1665), who spent a good deal of time in the Netherlands, was also a well-known connoisseur and collector of art in that country. A 1663 entry from the diary of De Monconys indicates that he visited Vermeer in Delft. Jan was unable to sell De Monconys any of his works. Yet the opinionated diplomat did comment on a Vermeer painting that had been sold to a local baker. De Monconys felt that the small painting, which contained only one human figure, had been priced too high. The value of a painting in the 17th century was often based on the works' size, complexity and amount of fine detail. Vermeer rarely produced any large works and typically stuck to subjects with only one or two figures.

Further international attention came in 1672, when Vermeer was asked to travel to The Hague and help settle a dispute involving an aristocratic German art patron. The patron, Prince-Elector Friedrich-Wilhelm I (1620–1688) of Brandenburg, questioned the authenticity of several Italian Renaissance paintings offered to him by the dealer Gerard van Uylenburgh (c. 1625–1679). Vermeer and his party declared the paintings to be fakes, and records show that Van Uylenburgh went bankrupt several years later.

An Ignominious Death

Sadly, Vermeer's life would take an unfortunate turn shortly after this trip. The year 1672 saw the beginning of war with France and a sharp decline in the prices of paintings. Vermeer would spend the rest of his life trying to make ends meet, and his artistic production dropped off dramatically. These business failures put severe strain on the painter's family, and likely led to his demise in 1675. Real international fame would only come to Vermeer long after his death.

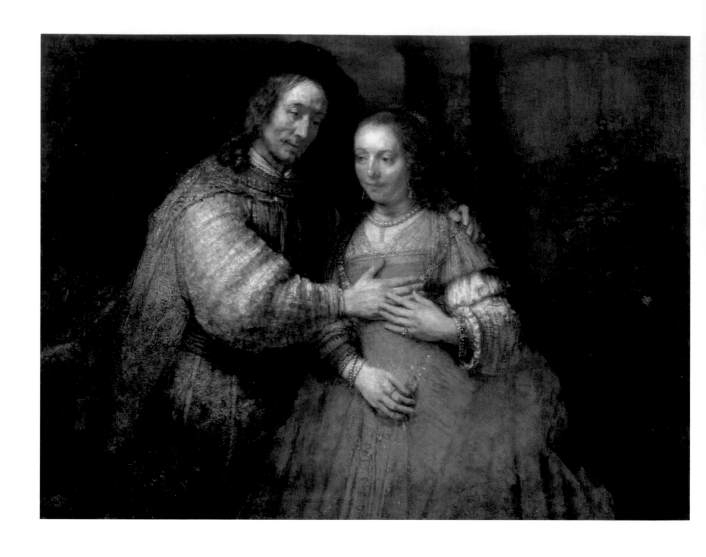

A famous master Rembrandt van Rijn became one of the most renowned Dutch painters during his lifetime, and this fame continued to grow after his death. Rembrandt's exquisite image of a loving couple reveals his greatest strengths as an artist, including a profound understanding of human character and a sensitive use of light.

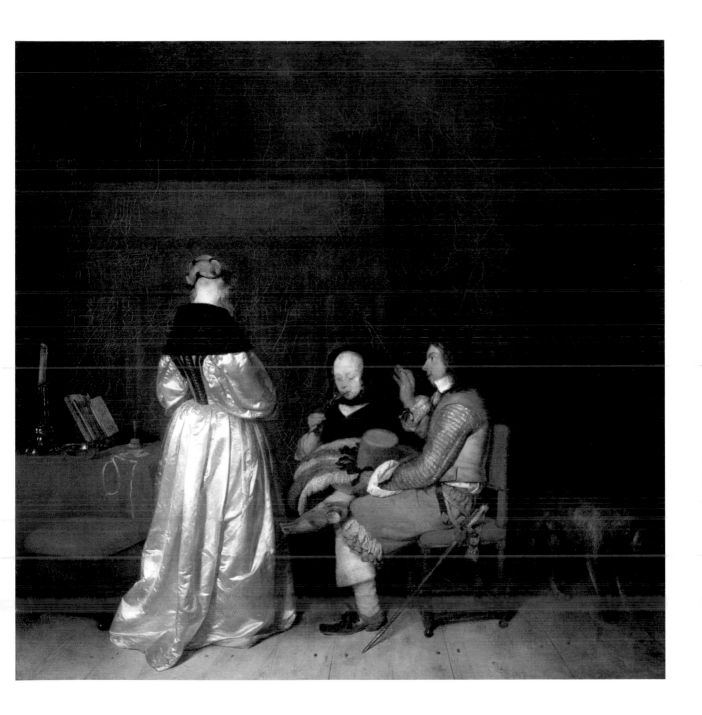

A mysterious scene The true meaning of some early Dutch paintings is not always clear. For many years, this image by Gerard ter Borch was thought to be an innocent conversation between a father and daughter. However, modern restoration of the painting found that the man is holding a coin in his raised hand. Thus the elegantly dressed standing woman is likely a prostitute.

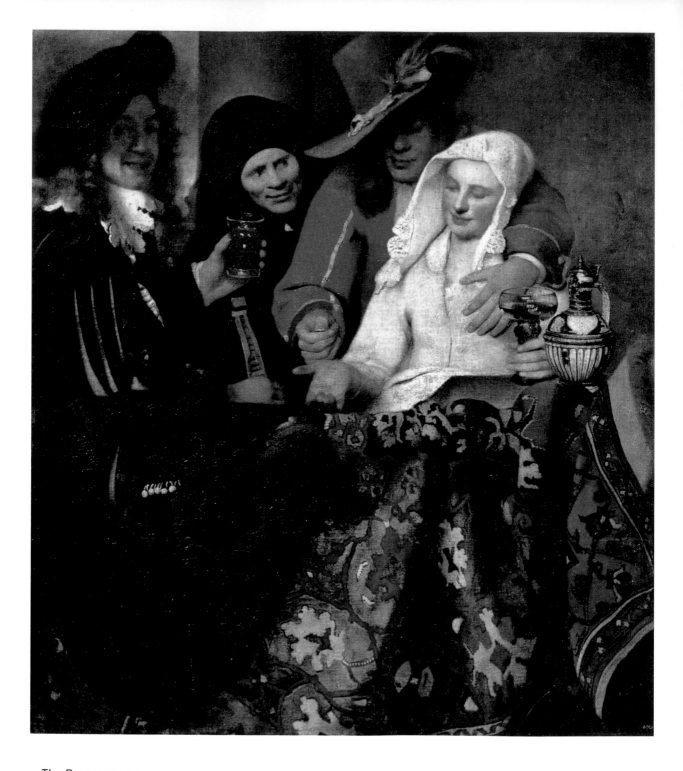

The Procuress Unlike Gerard ter Borch's *Gallant Conversation* (page 29), this early Vermeer work clearly depicts the world of the Dutch brothel. The man in the red coat is paying for sex as he places his hand on the woman's breast.

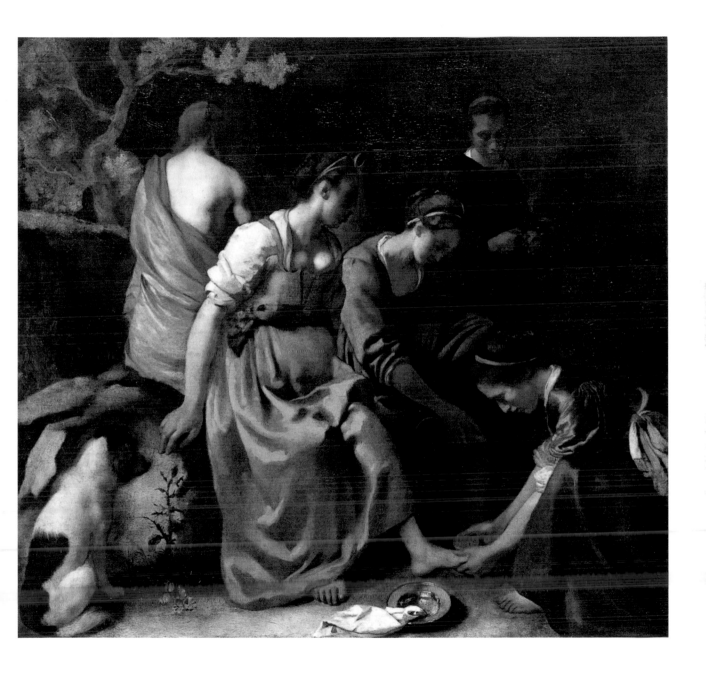

Faithful women Another early Vermeer work shows the Roman goddess Diana surrounded by her attendants. Though Diana was a figure from Pagan mythology, Vermeer likely intended the painting to remind people of Christ washing the feet of his disciples.

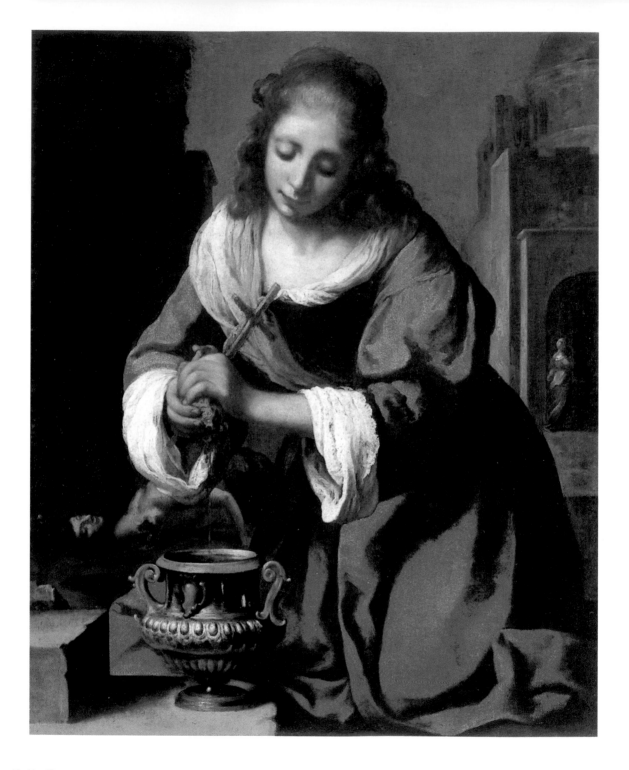

Catholic roots Vermeer converted to Catholicism shortly before his marriage to Catharina, and his first works show an interest in Catholic iconography and Italian painting techniques. This image of Saint Praxedes, a woman who cleaned and buried the bodies of early Christian martyrs, was copied from a work by the Italian artist Felice Ficherelli.

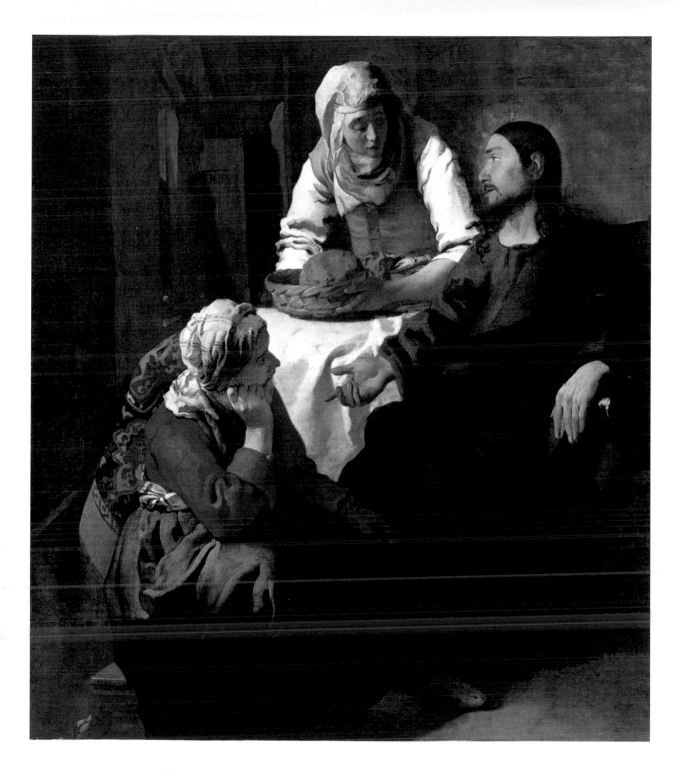

Christ in the House of Mary and Martha This canvas resembles *Saint Praxedes* in many ways, with its dark background, dramatically lit central figures and Catholic themes. As Vermeer matured, his style would change considerably. The dusty Italian scenes would be replaced by sunlit images of the Dutch middle class.

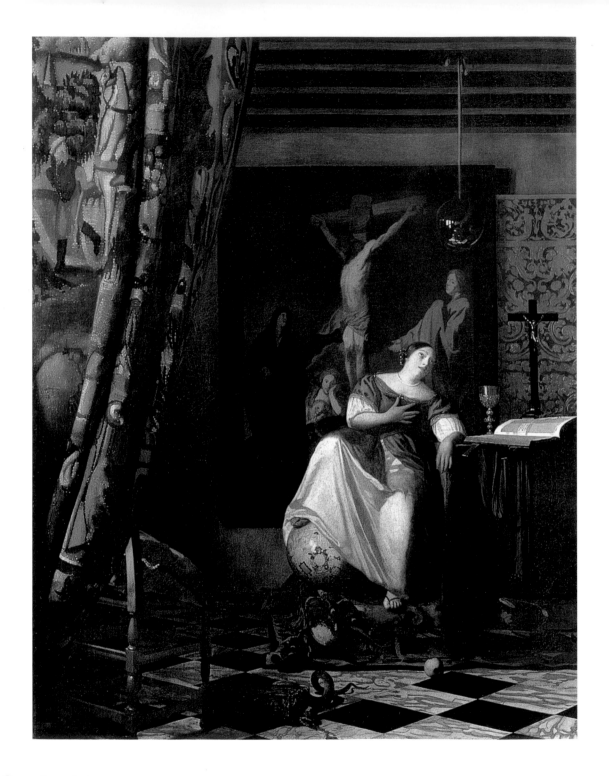

Sacred symbol The mature Vermeer did not completely abandon Catholic iconography. *Allegory of Faith*, painted in the 1670s, uses the characteristic imagery of Vermeer's secular interior scenes, including the drawn-aside tapestry and precisely aligned floor tiles. But it also features Jesuit images, such as the prayerful figure of faith and the vanquished snake—symbol of sin—on the floor. Most scholars believe that Vermeer painted this work to satisfy a commission from the local Jesuit community in Delft.

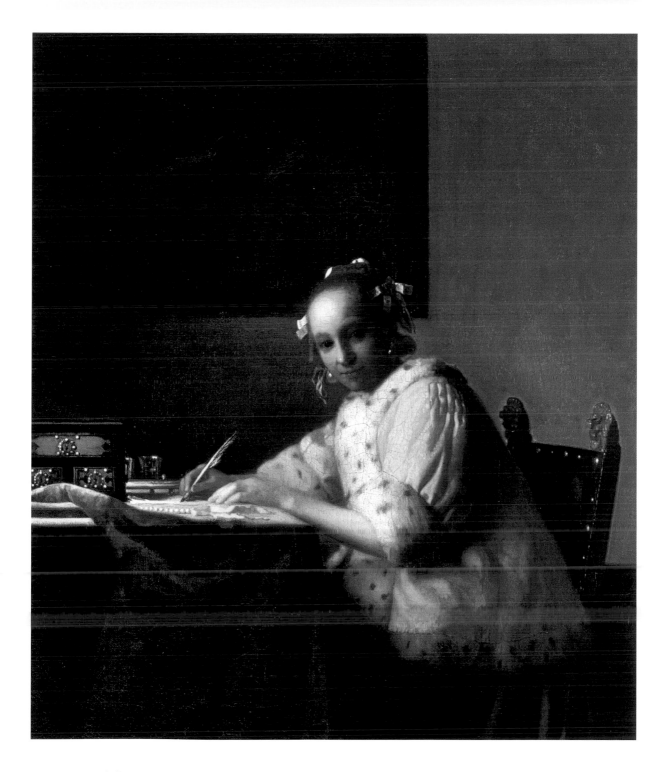

Secular model Even when not placed in an overtly sacred painting, Vermeer's women often have a dignified appearance. This letter writer seems just as purposeful as the lady in his *Allegory of Faith*. Vermeer clothes his secular model in a yellow, fur-lined satin jacket that he would use in numerous other paintings.

Art

"Painting is the grandchild of nature. It is related to God."

Rembrandt
van Rijn

Luminous stillness...

... is a hallmark of nearly all Vermeer's work. He achieves this through his carefully ordered compositions and his remarkable ability to depict the play of light on people, buildings and objects. Vermeer also had a deep understanding of human character, and his sensitively portrayed women and men still captivate us today.

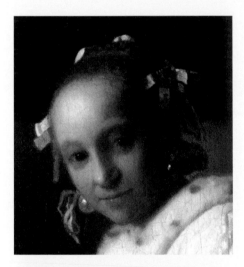

Vermeer's Women

Vermeer loved painting female figures. Not surprisingly, many women played vital roles in the painter's life, including his mother-in-law, wife and numerous daughters. Jan developed a keen sensitivity to women's facial expressions and attitudes that was rare among painters of his day, who were nearly all men. Indeed, Vermeer's women seem strikingly real to modern viewers.

Vermeer's signature...

 ... occurs in different forms on different paintings. Sometimes the painter spells out his name as "Johannes Vermeer." For other works, he uses only a simple monogram. Scholars believe some of the signatures on authentic Vermeer paintings are not genuine.

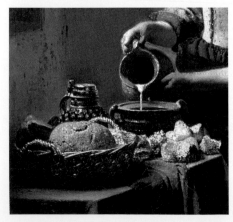

Timeless scene: a light-dappled detail from Vermeer's *The Milkmaid* (page 72).

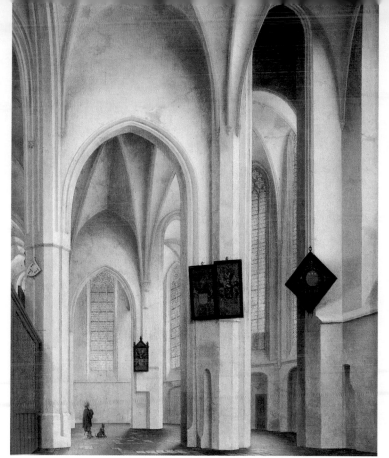

The Dutch City

Dutch painting chronicled the physical development of their cities as no society had done before. Accurate paintings of churches, town halls and cityscapes provided a remarkable record of the changes that occurred in the Netherlands during the 17th century. The painter Pieter Jansz. Saenredam (1597–1665), for example, produced expressive interior "portraits" of churches, many of which had been stripped of their Catholic holy images, and also finely rendered views of Dutch cities (page 9). Vermeer followed the example of artists like Saenredam by producing two exquisite images of his hometown (pages 62, 64–65).

Art and the Everyday

Many artists of the Dutch Golden Age found inspiration in the commonest objects and activities. Yet few of them were as successful at painting everyday life as Jan Vermeer. Vermeer's brush gave vibrant life to pitchers, tablecloths, decorative tiles, furniture and even foot warmers. His canvases ennoble the activities of milkmaids and lacemakers. Jan helped bring a sense of dignity to middle-class life, a dignity his middle-class buyers would have appreciated.

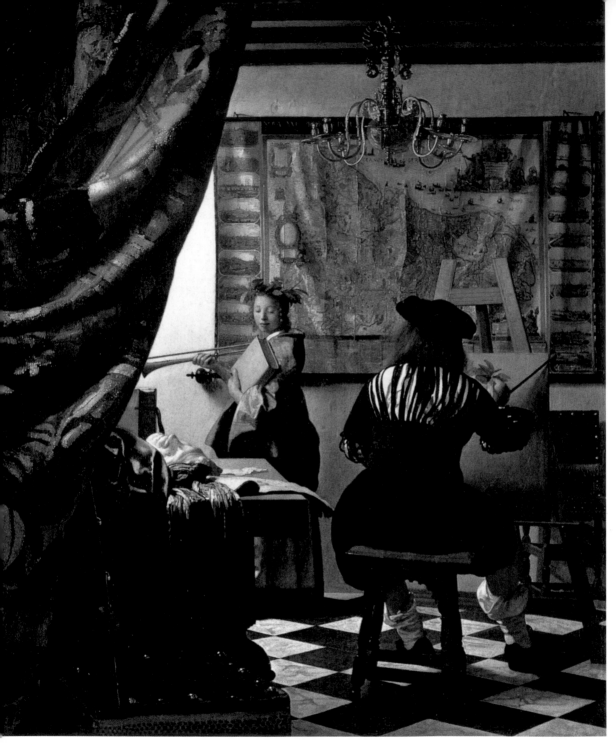

In his theatrical *Art of Painting*, Vermeer stresses the importance of the artist in society. The painter and model carry out their work under the huge map of the Netherlands, a clear symbol of Vermeer's homeland.

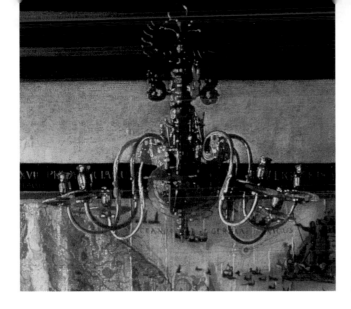

The lustrous, reflective chandelier from Vermeer's *Art of Painting*.

The Poetry of Light and Perspective

"I went to see a celebrated painter named Vermeer ... [who] showed me some examples of his art, the most extraordinary and most curious aspect of which consists in the perspective."
Dutch aristocrat Pieter Teding van Berckhout (1643–1713)

A Small But Influential Output

Of the fifty or so paintings created by Vermeer, only about thirty five still exist. These works have an almost photographic quality for modern viewers, and the artist probably impressed people of his day with his ability to mimic reality. Vermeer's canvases incorporate a variety of influences and techniques, as well as symbolic meanings.

Jan developed a complicated painting technique that often proved slow and painstaking. He used the highest quality materials, especially in his choice of paints. His vibrant blue pigments, including natural ultramarine and lapis lazuli, remain hallmarks of his work. Vermeer often built up his canvases with many layers of paint, and he defined objects using careful shading. Up close, the boundaries of objects look somewhat fuzzy, and one almost never detects clearly drawn

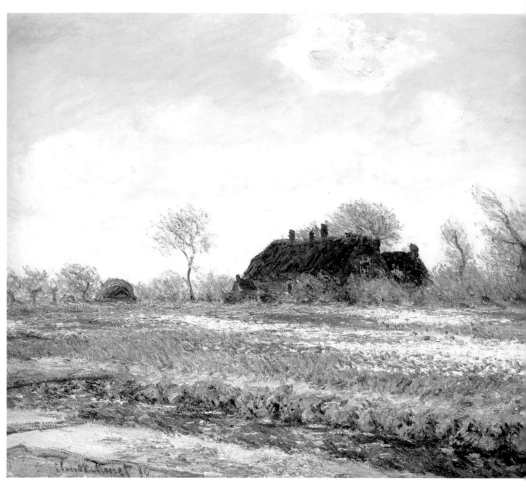

Vermeer's obsession with light was shared by many artists of later generations. Impressionist painter Claude Monet visited the Netherlands in 1886, when he painted this image of a farmhouse and tulip fields near Leiden.

lines at the edges of figures. When finishing a work, Jan often would add a layer of colored glaze to certain areas in order to give them subtle highlights and a greater luster.

The Drama of Light

In his work, Vermeer reveals a fascination with the quality of natural light, as well as the ability of light to enhance the drama and meaning of an image. Vermeer expressed light not only with color but also with a technique called pointillism. This technique involves applying small dots or blotches of paint to various objects within the painting. When seen from a certain distance, the blotches resemble the shimmer that natural light produces on various surfaces. One dramatic example of Vermeer's pointillism is the monumental hanging drapery from his *Art of Painting* (page 40). Other instances include the hanging ivy in *The Little Street* (page 62) and the sun-dappled food on the table of *The Milkmaid* (page 72). Vermeer's rendering of light gives his paintings a subdued brilliance that later artists would admire. Claude Monet (1840–1926), Georges Seurat (1859–1891) and many other 19th-century painters devel-

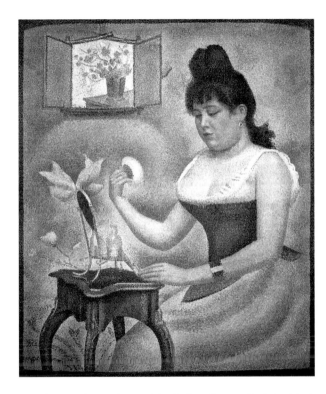

The pointillist works of 19th-century master Georges Seurat use dots of pure color to represent light and form. Vermeer also used a kind of pointillism, but his technique was confined to specific areas of his canvases.

oped an obsession with light. Seurat's pointilist technique, in which dots of pure color are used to express light and form, somewhat resemble Vermeer's earlier technique.

The Mastery of Perspective

Beginning in the 15th century, many European artists became fascinated with the depiction of three-dimensional space. By Vermeer's time, the accurate use of central perspective was considered necessary for any painter of quality. Dutch theorist Hans Vredeman de Vries (1527–c. 1609) produced his country's most famous scholarly work on perspective, one that many painters used as an essential guide.

In central perspective, objects within a painting become gradually smaller and closer together as they get closer to a location called the vanishing point. The nearer an object is to the vanishing point, the farther away it appears to be. Lines called orthogonals lead to the vanishing point, and they provide the painter with a guide for determining how much an object should appear to recede.

Recent scholarship has found that Vermeer used a particular method to help him master central perspective. He would secure his canvas to a wall, table or other surface. He then would punch a tiny hole at the painting's vanishing point. Using a pin, Vermeer would attach one end of a chalk-covered string to the hole. He then would draw the string tightly across the canvas so that it followed a correct orthogonal line. Finally, the string would be pulled back and released so that it marked the orthogonal line with chalk. Vermeer could later trace the chalk line using a pen-

Painters of the 1600s studied perspective carefully, and they often used camera obscuras and other tools to achieve accurate three-dimensional space in their works. The illustration on the right comes from Hans Vredeman de Vries' book *Perspective*, published in 1604–1605. The illustration in the center shows how an image is produced by the lens in a camera obscura.

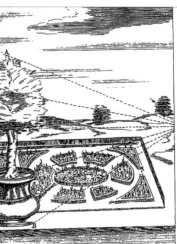 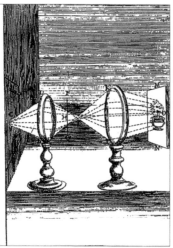

cil or paint. Modern X-ray images have found traces of pinholes at the vanishing points in many of Vermeer's works.

Did Vermeer Use a Camera Obscura?

For many years, scholars believed Vermeer made extensive use of a camera obscura when creating his paintings. In the 17th century, the most sophisticated type of camera obscura was a box that contained a mirror at the back, a lens at the front, and a glass screen at the top. Light from an object or objects was transmitted through the lens. It then reflected off the mirror and produced an image on the glass screen. Many painters of the era would trace this image directly onto a canvas.

Today, many historians believe Vermeer did not trace his images directly from a camera obscura. However, he probably did use the device as a guide for achieving certain effects within his paintings. In the camera obscura image, various parts of an object appear somewhat fuzzy and less precisely defined. Some of Vermeer's paintings depict details in a similarly fuzzy manner. Characteristic examples include the threads in *The Lacemaker* (page 46) and the chair and clothing from *Girl with a Red Hat* (page 47).

Early Works: The Influence of Catholicism

Vermeer's earliest paintings show a painter still learning his craft. He had not yet mastered spatial perspective, and his color schemes and brushwork

An X-ray image of *The Milkmaid* (page 72) reveals that Vermeer made a tiny pinhole at the painting's vanishing point. He likely attached a chalk-covered string to this pinhole to create accurate perspective lines on the canvas. These aids would have helped him produce a realistic interior space.

are slightly cruder than in his mature paintings. Also, the overtly religious subjects of these early works differ radically from those of his later career. The young Vermeer, a recent convert to Catholicism, appears to be exploring the iconography of his newly acquired faith.

One of Vermeer's earliest works, *Saint Praxedes* (page 32) clearly exemplifies his interest in Catholic imagery. St. Praxedes, an early Christian woman, lived in Rome during the 2nd century. She is thought to have buried the bodies of many martyred Christians, and Vermeer's painting depicts her collecting blood from one of the martyrs. To emphasize the spiritual intensity of this scene, Jan darkens the background and highlights the central figure with a bold, almost theatrical light. Such techniques were first developed by Italian painters, most notably Michelangelo Merisi da Caravaggio (1573–1610). In fact, Vermeer based his *Saint Praxedes* directly on a work by the Florentine artist Felice Ficherelli (1605–1660).

Paintings like *Saint Praxedes* were common in Catholic homes during Vermeer's day. They helped promote the ideals of the Counter Reformation, a movement that tried to strengthen the faith of Catholics and prevent the further spread of Protestantism. Vermeer experimented with this artistic tradition for only a short time. Soon he would develop the less emotional, more naturalistic style for which he is famous.

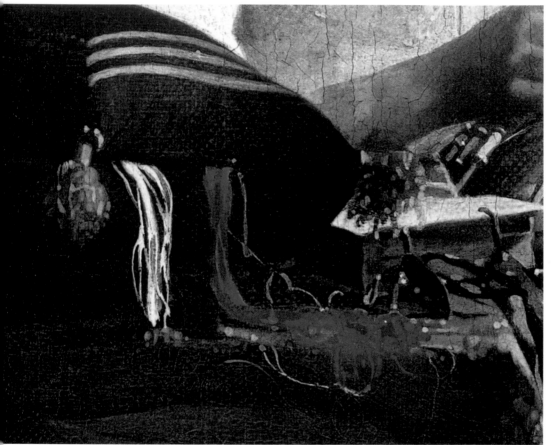

The white and red threads from *The Lacemaker* (page 48) have a bright, fuzzy quality that resembles the images produced by a camera obscura. Vermeer may have used this tool as part of his artistic process.

Vermeer's interior scenes may appear simple at first. But his exquisite use of color and light, along with his remarkable ability to depict human expressions, give these works a luster and complexity that few other 17th-century artists could match. The people in Vermeer's world often possess a certain mysterious quality, a quality that makes the viewer want to know more about them.

The Art of Intimacy: Vermeer's Domestic Scenes

The vast majority of Vermeer's output consists of intimate interior scenes. Most of his interiors include one or two people, mostly well-to-do women, performing simple activities or engaging in moments of contemplation. This type of painting became a specialty of many painters in Delft. Along with Vermeer, Pieter de Hooch and Gerard ter Borch helped to develop and perfect the genre.

Exquisite Materials

One of the most famous examples of this type of painting is *Lady with the Water Pitcher* (pages 51, 55). Here Vermeer masterfully depicts a wide vari-

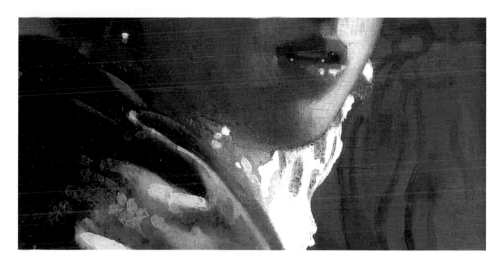

Lips and clothing from *Girl with a Red Hat*: more Vermeer details possibly inspired by the camera obscura.

ety of materials. The woven table cloth has a silky sheen, and its patterned designs are reflected in the lustrous tray holding the pitcher. For the leaded glass window, Vermeer uses natural ultramarine pigments to reveal the subtle passing of light through the panes. Also remarkable is the map of the Netherlands, where the artist suggests minute details without actually painting them. Finally, the woman's satin jacket and soft linen cowl contrast beautifully with her creamy skin. Many scholars believe that this image actually depicts a woman preparing her toilette.

Vermeer and Symbolism

Two other famous Vermeer women, *The Milkmaid* (page 72) and *Woman Holding a Balance* (page 50) appear in paintings with strong symbolic meaning. *The Milkmaid* features some of Vermeer's most beautiful coloring, including the rich yellows and blues of the maid's attire. Light floods into the well-balanced scene, and pointillist highlights enliven the loaves of bread, baskets, and earthenware on the table. These details, along with the serene countenance of the woman, suggest that Vermeer wanted the painting to represent feminine virtue.

Woman Holding a Balance (page 50) is one of Vermeer's most overtly symbolic works. Though it uses the same dazzling techniques as Vermeer's other paintings, the viewer is immediately struck by the moral theme of the picture. A collection of jewelry sits on a table in front of the woman, while a painting of the Last Judgment hangs on the wall behind her. The jewelry represents worldly wealth, while the religious painting reminds the viewer that wealth does not guarantee—and often prevents—Christian salvation. The quiet confidence of the woman holding the balance indicates that she understands her moral duty to "weigh" the virtues of worldly success and spiritual strength. Vermeer's carefully composed image presents this moral subject in a subtle and effective manner.

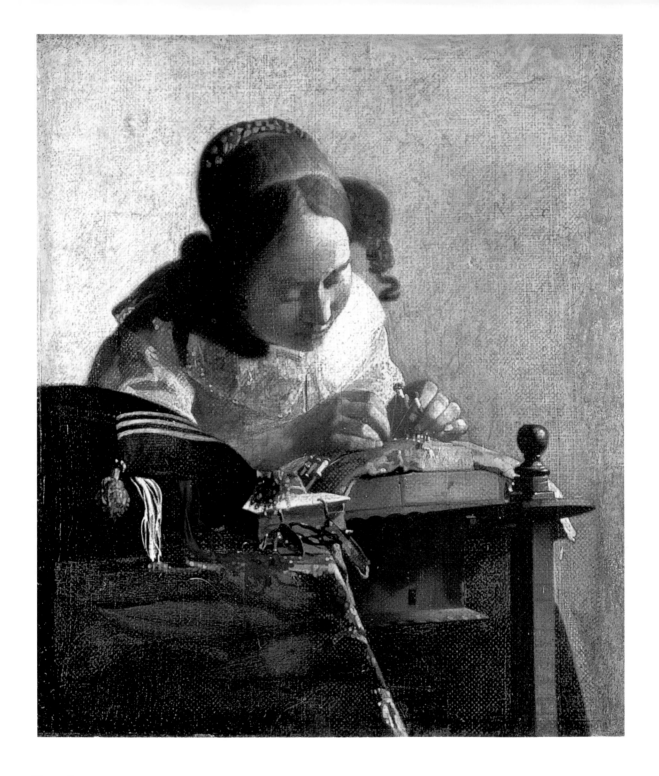

At work Vermeer's lacemaker pursues her task with single-mindedness and diligence. This small painting creates a beautiful and informative composition, showing the bobbins, pins, thread and other tools of the lacemaking craft.

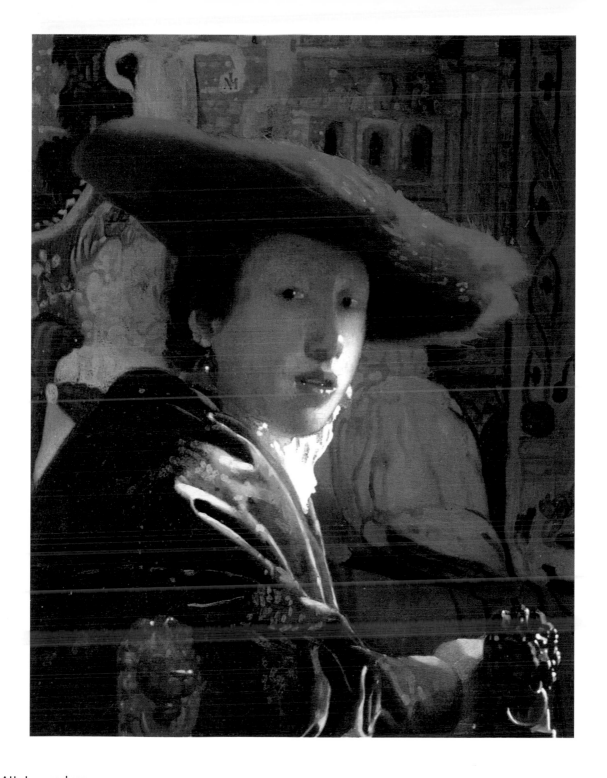

All dressed up Though not as industrious as the lacemaker, the woman in *Girl with a Red Hat* is equally engaging. The picture's fuzzy details, achieved through somewhat abstract brushwork, give the painting an almost impressionistic quality.

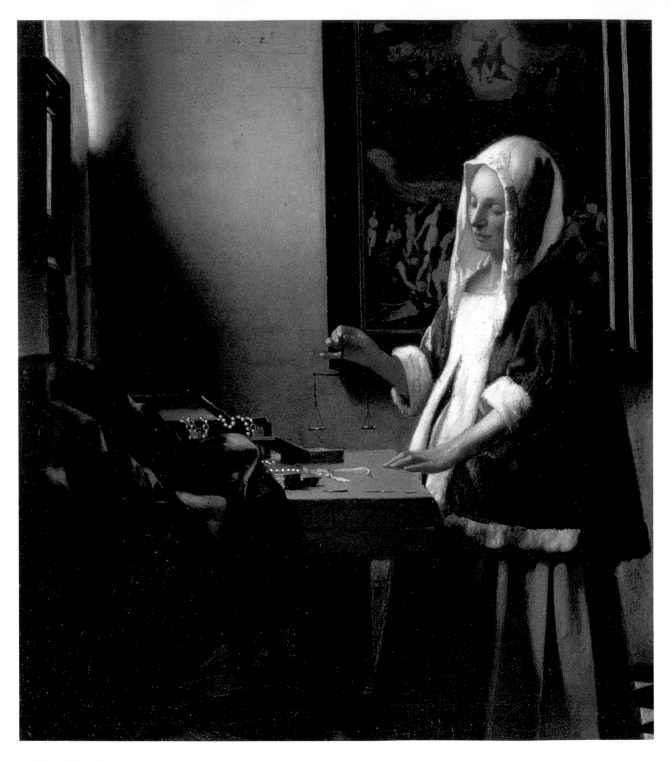

Morality tale In *Woman Holding a Balance*, Vermeer uses his refined painting techniques to convey a simple moral message. The woman stands next to a table on which can be seen lustrous jewelry and coins, symbols of worldly wealth. Behind her hangs a painting of the Last Judgment, representing Christian salvation. Thus the balance likely symbolizes a Christian's duty to "weigh" material success against spiritual virtue.

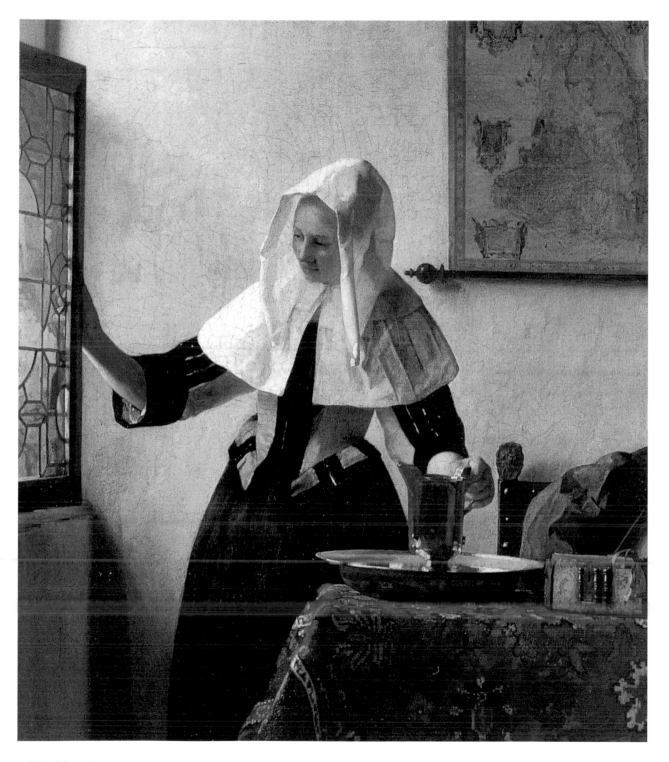

Ideal beauty *Lady with a Water Pitcher* depicts one of Vermeer's most idealized women. Her beautiful features and modest bearing are highlighted by the exquisite objects that surround her.

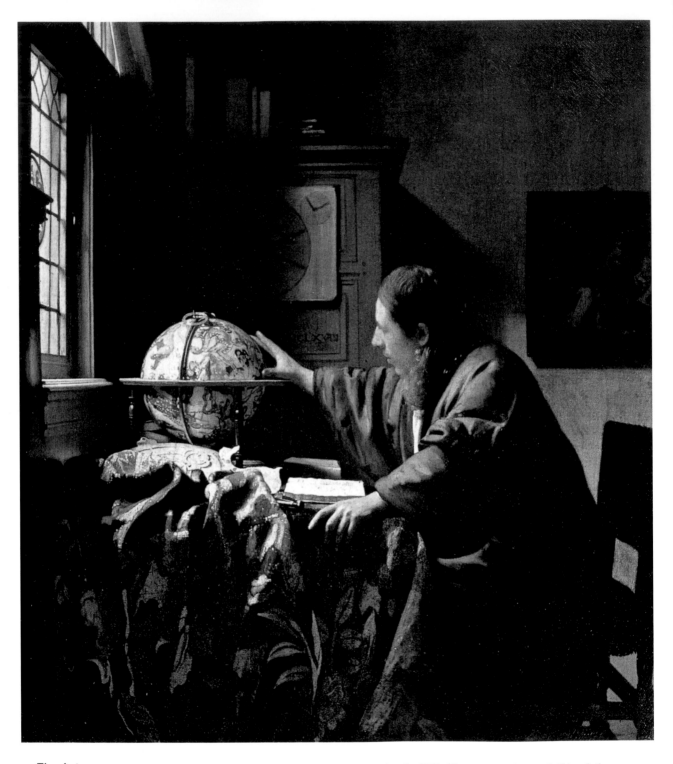

The Astronomer Many Dutch intellectuals developed a passion for science during the 1600s. The contemplative man in this painting, surrounded by the finest scientific instruments, probably represents Vermeer's attempt to portray the ideal scholar.

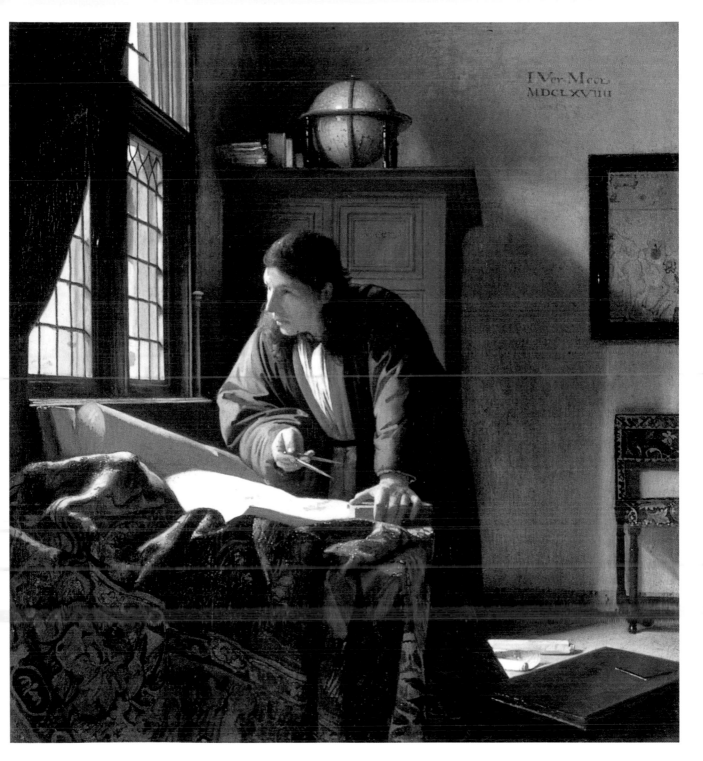

The Geographer Painted at the same time as *The Astronomer*, this work presents another version of Vermeer's ideal scientist. The similarity in appearance of these two figures suggests that the same man modeled for both paintings.

In the window from his *Lady with the Water Pitcher* (page 51), natural ultramarine pigments help reveal the passing of light through the panes.

The Pearl Earring and the Red Hat

Vermeer's interest in the human face is best shown in two portrait-like works, *Girl with a Pearl Earring* (page 24) and *Girl with a Red Hat* (page 49). *Girl with a Pearl Earring* has become one of Vermeer's most famous images. The young woman's frank stare and unusual costume differ markedly from typical female images of the time. As usual, Vermeer portrays the play of light on surfaces with remarkable effectiveness. The girl's creamy, smooth skin perfectly complements the satiny texture of her clothing. Tiny pools of light moisten her lips and eyes and add luster and depth to the magnificent earring. All of this remarkable technique is further emphasized by the painting's stark background. The girl and her earring have a directness and immediacy that make them come to life in the viewer's eyes.

Girl with a Red Hat portrays another engaging face. Yet this young woman is less idealized than the one with the pearl earring. Her features are less regular, and she seems to possess a more specific, defined personality. This personality is enhanced by the daring hat and the mysterious glance. Vermeer also uses somewhat different painting techniques here than he does for *Girl with a Pearl Earring*. The brush strokes are freer and more abstract, and the color scheme are bolder. These details give the painting a more mysterious, atmospheric quality.

A Passion for Science

Anthony van Leeuwenhoeck of Delft (1632–1723) was one of the most important scientists of the 17th century. He had made vitally important improvements to the microscope, and he also advanced the understanding of blood circulation. This passion for science had become a major feature of Dutch life during the 1600s. Vermeer himself paid homage to scien-

Beautifully rendered materials from *Lady with the Water Pitcher* (page 51) include the woman's creamy skin, the patterned textile and the reflective pitcher and tray.

tific learning in two works entitled *The Astronomer* (page 52) and *The Geographer* (page 53).

In both of these paintings, Vermeer probably used the same model. Some historians hypothesize that Van Leeuwenhoeck may have been that model, as he later helped negotiate Jan's family debts after the painter's death. Most likely, however, Vermeer intended the astronomer and geographer to symbolize the virtue of scientific learning, and not to represent living people. Many wealthy Delft citizens considered the private pursuit of science to be an integral part of a complete, civilized life. Vermeer, who spent a good deal of time studying art-related scientific concepts, including perspective and light, may have felt a special connection with the subjects of these paintings.

A Musical Composition

The Music Lesson (pages 60, 61) nicely displays Vermeer's talent with composition and with achieving the illusion of three-dimensional space. Here he features a complex arrangement of interlocking rectangular and diamond-shaped forms. These forms include the clavecin, an early keyboard instrument, as well as the floor tiles, windows, mirror and painting. Vermeer further accentuates the spatial complexity of his work by showing the reflection of the floor tiles in the mirror. For the perspective of the scene, see page 57.

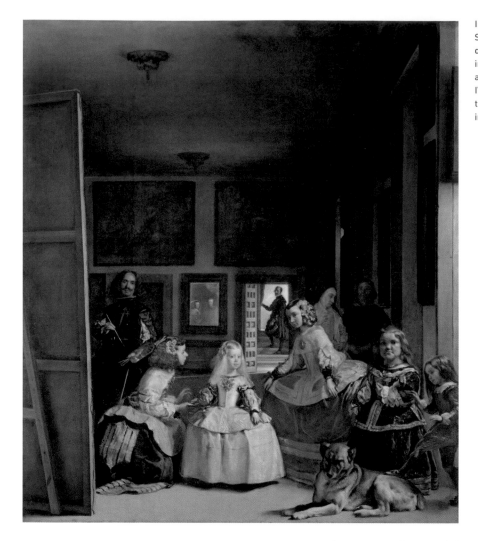

In his famous work *Las Meninas* (1656), Spanish artist Diego Velázquez created a dramatic spatial composition. The painter in the scene—a self-portrait of the artist—observes his subjects, King Philip IV and Queen Maria Anna of Spain. But the royal couple appear only as reflected images in the mirror on the back wall.

Within *The Music Lesson*'s composition, the two people become relegated to the background. Far more prominent is the elegant table, on which lie a luminous porcelain pitcher and a glistening silver tray.

Allegory and Vermeer's *Art of Painting*

Vermeer's most remarkable interior composition, however, may be his allegorical *Art of Painting* (page 40). This masterpiece brings together all of Vermeer's talents as an artist, including realistical-ly portrayed materials, carefully balanced forms, and the remarkable play of light. Yet the painting also offers more dramatic flair than do his other domestic scenes. The elaborate drapery, which re-sembles the curtain of a stage, is partially pulled aside to reveal the "actors" in the scene. The dif-ferent elements of that scene all have symbolic meaning. Vermeer scholars believe that the painter represents art; the woman represents Clio, the an-cient Muse of History; and the laurel crown on Clio's head symbolizes fame. The combination of these symbolic elements, along with the map of the

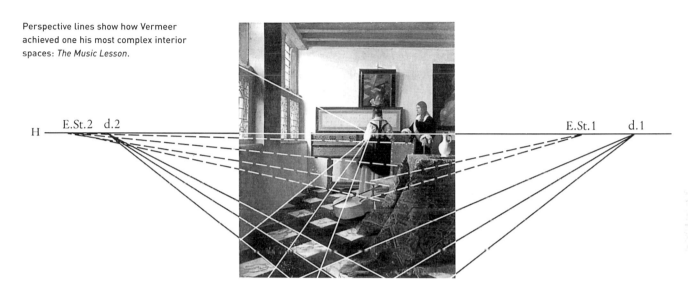

Perspective lines show how Vermeer achieved one his most complex interior spaces: *The Music Lesson*.

Netherlands on the wall, reveals the allegorical meaning of the image. Vermeer is suggesting that the work of an artist will bring lasting fame to his or her country.

It is interesting to compare Jan's *Art of Painting* with another widely admired 17th-century image. *Las Meninas* (page 56) is the masterpiece of the Spanish painter Diego Velázquez (1599–1660). Like his contemporary Vermeer, Velázquez strongly believed in the importance of artists in society. Both *Las Meninas* and the *Art of Painting* show off the talents of their authors with sophisticated spatial compositions, dazzlingly rendered materials, and engaging human subjects.

Images of Delft

Two of Vermeer's paintings show him leaving the confines of his studio and portraying the buildings of his home town. The first great architectural paintings of Delft were created by Haarlem artist Hendrick Cornelisz. Vroom (1566–1640). In both works, Vroom emphasizes the elaborate waterways and town walls, which protected Delft and enabled it to develop its powerful trading economy in the 1600s. Indeed, both of Vroom's paintings give Delft a grand, monumental appearance. Paintings like these often grew out public commissions, and they tended to glorify the wealth and prestige of a particular community.

After 1650, the new artistic climate in Delft led to the production of less grandiose architectural imagery. The paintings of Emanuel de Witte perfectly illustrate this change. De Witte's church interiors use oblique angles to achieve a more personal, intimate character. Similar qualities can be seen in the work of Daniel Vosmaer (1622–c. 1670), who focused on exterior views of Delft. One of his best works is *View of Delft through an Imaginary Loggia* (page 59).

Though not technically an architectural painter,

Hendrick Cornelisz. Vroom produced the first important views of Delft in the early 1600s. These works prominently featured the elaborate canals and walls that protected the city.

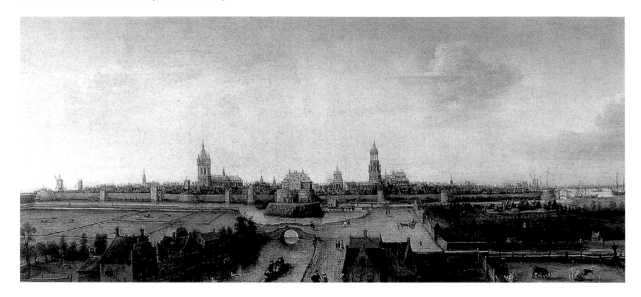

Pieter de Hooch brilliantly incorporated Delft's buildings into many of his outdoor scenes. His ingenious spatial compositions show how courtyards of houses lead into streets and canals. They also accurately depict details like brickwork, arched doorways, and small sculptural decoration.

The Introspective City

One of the most mysterious architectural views of Delft was produced by Carel Fabritius (page 22). This work uses perspective in an extreme way, and many scholars believe the painting was meant to be seen through a device called a perspective box. In this device, the painting would be placed on a curved surface and viewed through a small peephole. A reconstructed photograph of the painting shows how the image would have appeared through the perspective box. Yet this painting by Fabritius is more than just a nifty trick. The artist also imbues his scene with a dreamlike, introspective quality, which is exemplified by the thoughtful expression of the main figure.

Vermeer's Delft

Vermeer's own images of Delft, *The Little Street* and *View of Delft*, incorporate many of the ideas and techniques used by other painters. As with de Hooch's images, *The Little Street* (page 62) gives the viewer an intimate sense of domestic life in Delft. It also displays a remarkable love of detail. Vermeer reproduces details such as the ivy and the small brickwork repairs with great accuracy. More-

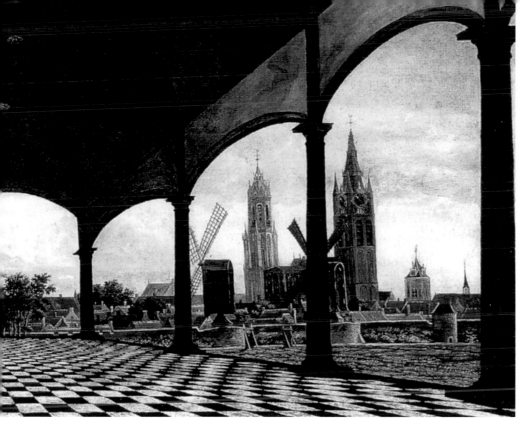

over, the painter's depiction of soft, natural light gives the painting a wistful quality reminiscent of the Delft of Fabritius.

Vermeer's grandest architectural image, however, is his *View of Delft* (pages 64–65, 66, 67). Unlike the works of Vroom, Vermeer's cityscape does not emphasize prosperity or strength. Instead, he presents Delft as a warm, inviting, lived-in place. The city gates, the bridge and the boats all show encrustations and other signs of age, and their images are gracefully reflected in the water. Ultimately though, Vermeer draws the viewer past these external trappings and into the sunlit rooftops and church tower in the heart of the city.

Daniel Vosmaer's *View of Delft through an Imaginary Loggia,* an example of the more intimate cityscapes produced in Delft after 1650.

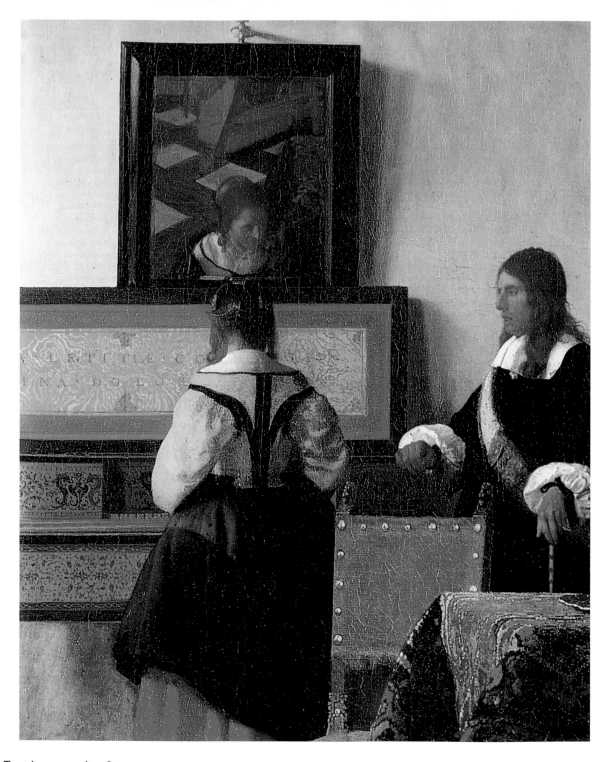

Teacher or suitor? Long ago, this painting acquired the name *The Music Lesson*. But is the elegantly dressed man a music teacher or merely a suitor? His gaze seems to be directed at the woman herself rather than her playing.

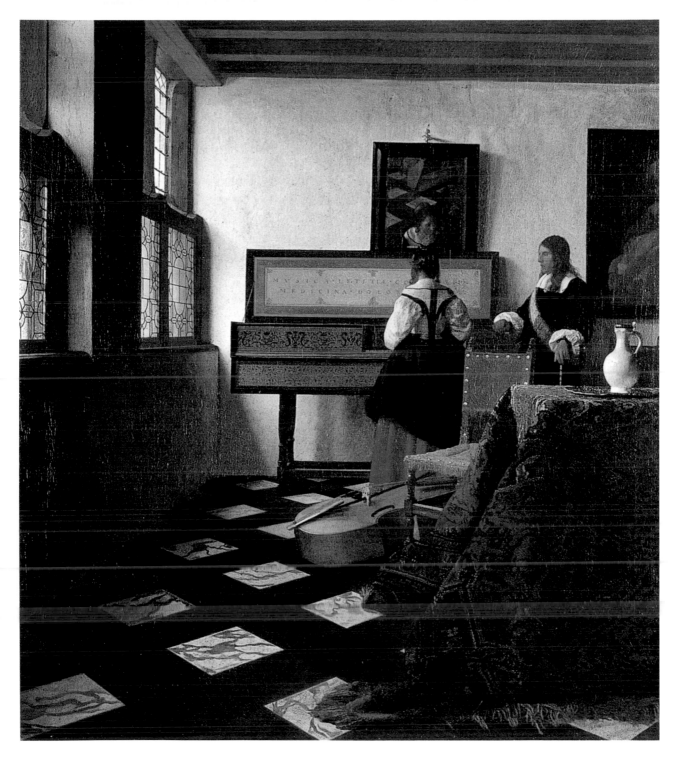

Complex geometry *The Music Lesson* represents one of Vermeer's most sophisticated spatial compositions. The rectangular and diamond-shaped forms of the windows, floor tiles, mirror and musical instrument provide a harmonious framework for the image.

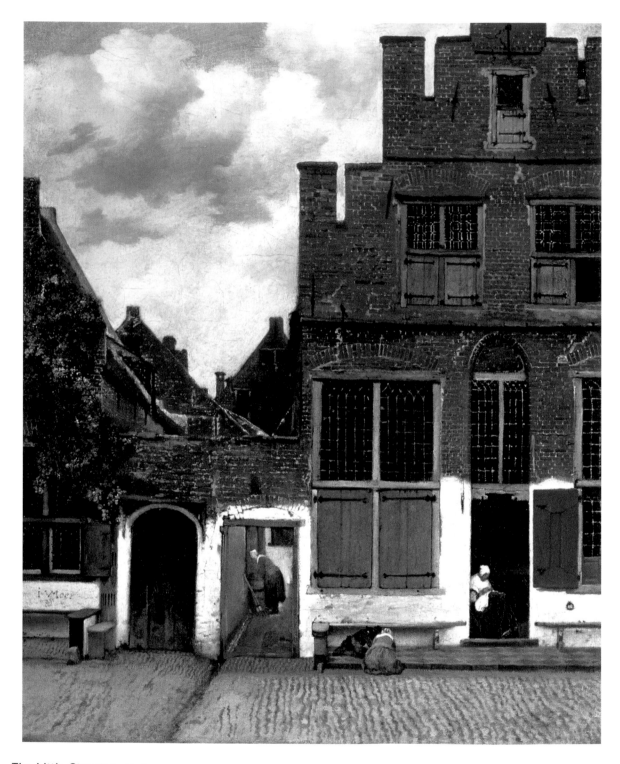

The Little Street Like his domestic interiors, Vermeer's asymmetrical street scene is enlivened by beautifully rendered materials, including the ivy, the partially repaired brickwork and the weathered shutters on the windows.

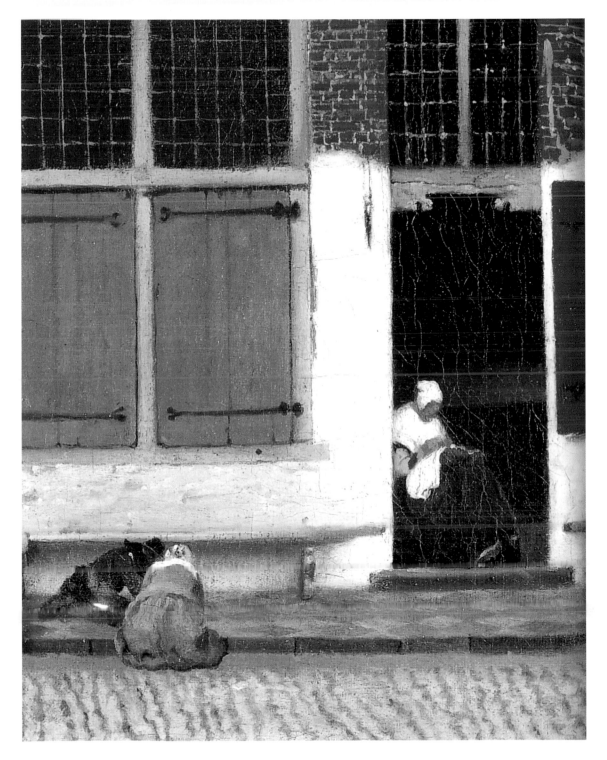

Everyday life The tiny figures within *The Little Street* show just enough detail to give them individual personalities. Collectively, they give the viewer a distinctive—if somewhat subdued—sense of urban life in 17th-century Delft.

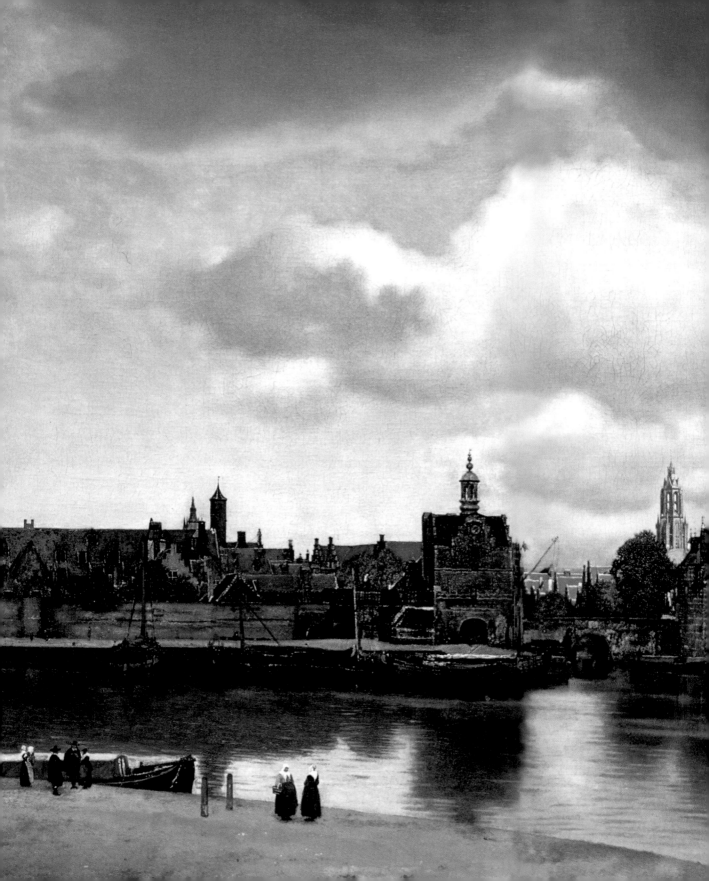

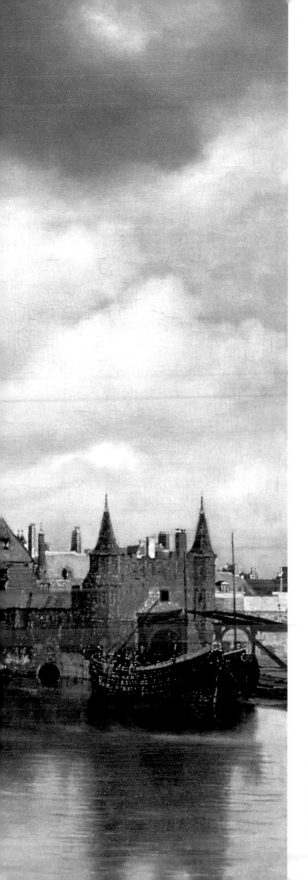

An atmospheric city Vermeer's greatest landscape painting, his *View of Delft*, does more than just portray the buildings and waterways. It also presents the viewer with an almost psychological impression of the city. The darkened gates and walls seem to protect the sunlit church spire and rooftops within. Vermeer's Delft is place where one can receive both shelter and emotional security.

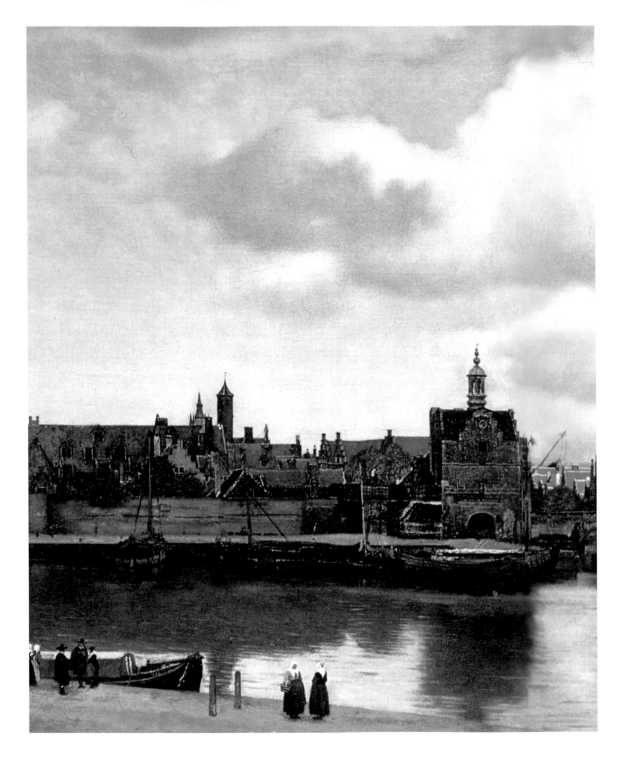

Quiet reflections Vermeer presents Delft's waterway as a shimmering, reflective pool, while the city walls and rooftops have a comfortable, weathered appearance. The normally busy port is populated by only a few human figures. All of these details enhance the contemplative nature of the painting.

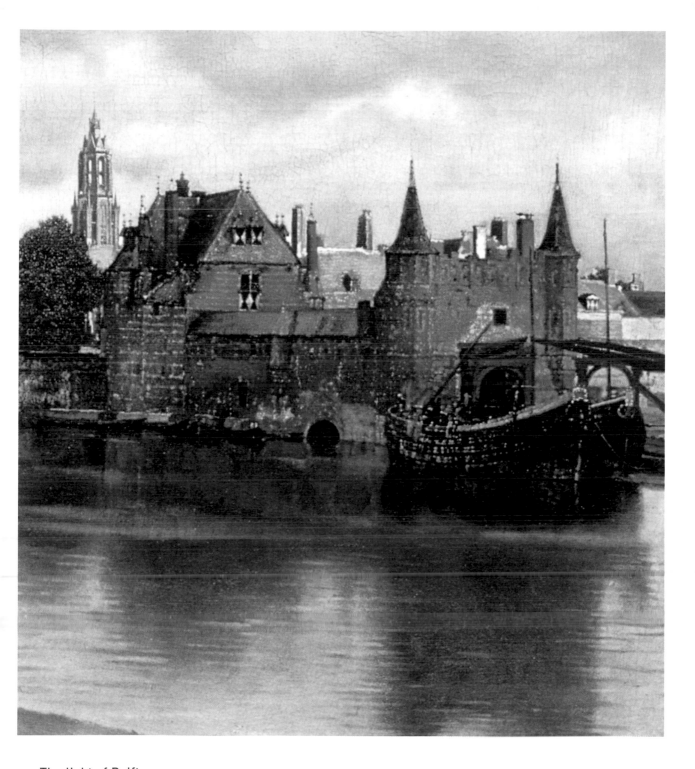

The light of Delft Vermeer uses different methods to portray the effects of light in *View of Delft*. Bright yellow and creamy pigments define the buildings of the sunlit interior. To suggest the play of subdued light, the artist covers his boat and city gates with pointillistic blotches of paint.

Life

"... had paid towards his
entrance fee 1 guilder,
10 stivers, balance
4 guilders, 10 stivers."

Payment record for Jan
Vermeer from the account
book of the Guild of St. Luke

An Amiable Man

From what we know of Vermeer, the painter made a good impression on almost everyone he met. His amiable personality helped him advance his career. Yet Vermeer ultimately fell victim to forces outside of his control.

An Extended Family

Many family homes in Delft sheltered multiple generations. Vermeer lived and worked in the house of his mother-in-law, Maria Thins (c. 1593–1680). His family would grow considerably, as he and Catharina would raise eleven children. The painter's household must have been a noisy, bustling place—quite unlike the calm, refined images in his paintings.

The Jesuits ...

→ ... officially known as the Society of Jesus, were founded in 1534 by Saint Ignatius Loyola (1491–1556) of Spain. The order established schools and communities throughout the Old and New Worlds. The Jesuits played a key role in preventing the spread of Protestantism to such places such as France, Austria, and southern Germany. The Jesuit community must have welcomed Vermeer, a convert from a Protestant family, with open arms.

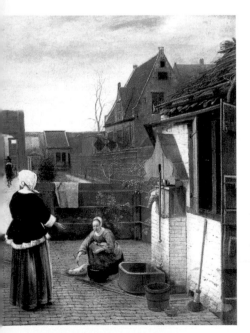

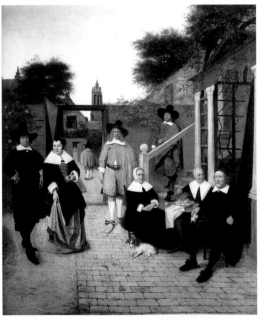

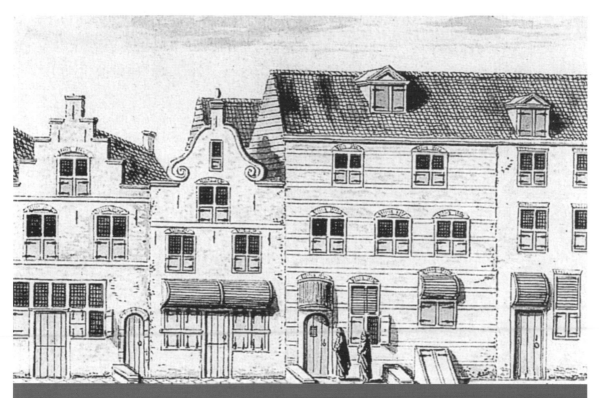

The Paepenhoeck

The area where Vermeer lifed in Delft, known the Paepenhoeck (or Papists' Corner), housed a wide variety of Catholic families. Rich and poor lifed side by side. The community's church, hidden away in a larger building, may have stood next to Maria Thins' house. Delft's Catholic community had to pay substantial taxes to the town in order to be able to run their churches.

Dressed for Success

In the 1600s, as today, clothes often revealed a person's social status or success in business. An inventory of Vermeer's possessions indicated that he owned ten collars and thirteen sets of cuffs, far more than the average citizen of Delft.

The clothes depicted in Vermeer's paintings show us how dress divided social classes. The earthy attire of the woman in *The Milkmaid* (page 72) for example, strongly contrasts with the elegant dress of the gentleman in *The Music Lesson* (page 61).

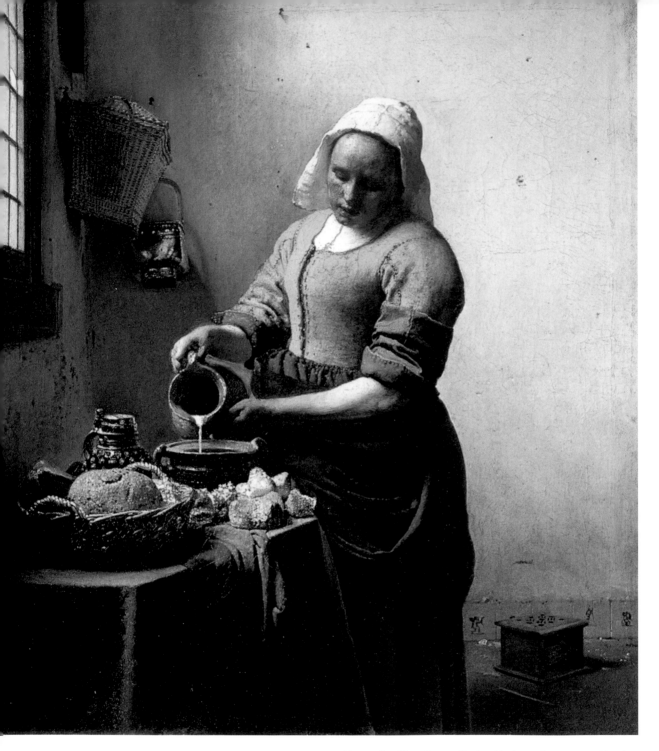

Vermeer's milkmaid wears the humble dress of a servant, yet her face bears a serene, almost noble expression. The food and containers on the table are arranged in the manner of a beautiful still-life composition.

Willem van Aelst's *Still-life with Fruit and Crystal Vase* was one of many that graced the homes of wealthy Dutch patrons in the 1600s.

Family and Studio: Successes and Failures

"In consequence of (financial losses) and because of the large burden of his children, having no personal fortune, he fell into such a frenetic state and decline that in one day or a day and a half he passed from a state of good health unto death."

Catharina Vermeer on her husband's untimely demise

Vermeer's Colorful Ancestors

Vermeer was born in 1632, the second child of a lower middle-class family in Delft. The family could boast a somewhat colorful history. Vermeer's paternal grandfather had been found guilty of producing counterfeit money, though he was able to avoid going to prison. Vermeer's father, Reynier Jansz. (1591–1652), trained as a silk weaver but later developed several other careers. Reynier married Jan's mother, Digna Baltens (*c.* 1596–1670), in 1615, and he adopted the surname Vermeer in 1640. A gregarious man, Reynier ran inns called the *Flying Fox* and the *Mechelen*.

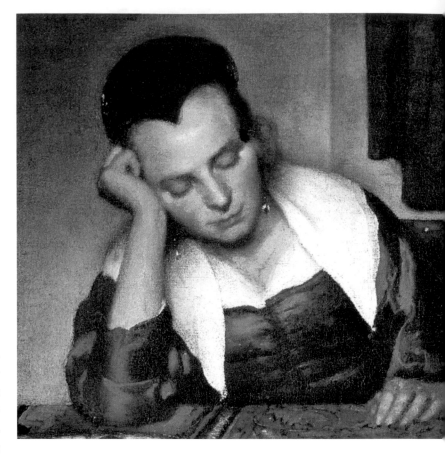

Vermeer's finely dressed sleeping girl (page 80) looks peaceful, but some scholars believe she may represent sloth or drunkenness.

Reynier also became a professional art dealer in 1631. During his childhood, Jan came into contact with many prominent artists in Delft, including Balthasar van der Ast (c. 1593–1657) and Pieter Groenewegen (c. 1600–1658). Such contacts probably inspired Vermeer to take up painting as career.

Historians know little about the early history of Jan's life. He almost certainly underwent an apprenticeship with a master painter, but we do not know who that painter might have been. Vermeer scholars speculate that the young Vermeer was trained in Delft, possibly by one of the painters associated with his father.

Marriage and Early Career

The year 1653 marked a key turning point in Jan's life. In April of that year, he converted to Catholicism and married Catharina Bolnes (1631–1688), a woman from a well-to-do Catholic family. Vermeer

and his wife probably moved into the house of Catharina's mother, Maria Thins, shortly after their marriage. Both would remain there for most of their lives. Maria had an extensive collection of paintings herself, and Vermeer seems to have enjoyed a warm relationship with both his wife and mother-in-law.

In December 1653, Vermeer registered with the Guild of St. Luke in Delft. Membership in this professional association included painters, sculptors and other artists. Art dealers too could register with the Guild, as Vermeer's father had done in 1631. Thus at the age of only twenty-one, Vermeer became an official master painter. However, he probably sold few works during the early years of his professional life. Only a

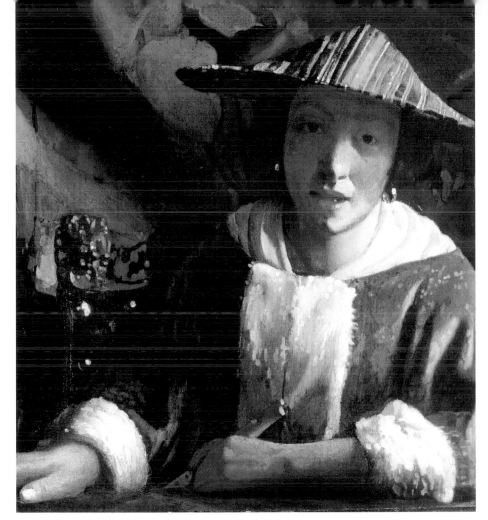

Though many critics doubt that Vermeer painted *A Young Woman with a Flute*, *c.* 1665–1670, the work closely resembles one of the artist's later canvases, *Girl with a Red Hat* (page 49).

The inventory also mentions that Vermeer's house had two ground level rooms, eight upper floor rooms, a basement, and an attic. Jan's immediate family probably lived and entertained in the downstairs quarters, while the basement provided additional sleeping space for the children. The painter likely set up his studio in a chamber upstairs. Most of the upstairs rooms, however, were reserved for the owner of the house, Maria Thins. Vermeer owned numerous paintings, several by well-known artists of Delft. For example, Vermeer's collection included several works by Carel Fabritius, one of the painters whose influence can be seen in Vermeer's own style.

small number of Vermeer's surviving paintings date from before 1656. Moreover, records indicate that Jan took about three years to fully pay the small six-guilder fee for joining the Guild of St. Luke.

Vermeer's Studio

An inventory of Vermeer's house has survived, and it lists many items that Vermeer used in his work. The inventory mentions painter's easels, canvases, palettes, and several items of clothing that probably were used in his paintings. The best known of these costume pieces is the yellow, fur-lined satin jacket seen in *Mistress and Maid* (page 82), *The Guitar Player* (page 83), *The Love Letter* (page 92), and several other works.

Mysterious Clients

Historians know the names of only a few of Vermeer's clients. The most important of them may

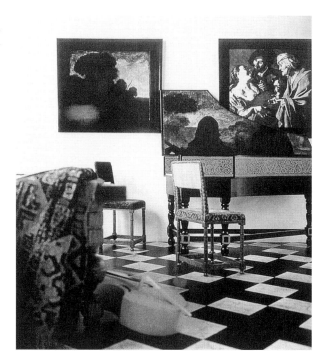

An inventory of Vermeer's possessions reveals that the artist owned much of the furniture, clothing and other items he used in his paintings. This contemporary photograph reconstructs how Vermeer might have set up the scene for his painting *The Concert* (page 86).

have been Pieter van Ruijven (1624–1674), a wealthy son of a brewer. Records show that Van Ruijven's children inherited about twenty paintings by Vermeer on their father's death. Given that only about thirty-five Vermeers have survived down to the present day, this inheritance represented a large percentage of his output. Records also show that Van Ruijven lent Vermeer money, further suggesting an artist-client relationship. However, scholars do not know how many paintings Van Ruijven may have acquired from Vermeer during the artist's lifetime.

Because Vermeer probably sold only a few pictures a year, the painter would have required income from other sources to support his large family. Historians know that Jan and Catharina did obtain inheritances from members of Maria Thins' family over the course of Jan's life. Vermeer also inherited the *Mechelen* inn from his father. However, none of these assets could have kept the family solvent for very long. Ultimately, Vermeer's financial troubles would prove to be his undoing.

Who Were Vermeer's Models?

Records indicate that the clothes, maps, globes and other items in Vermeer's paintings were based on objects owned by the artist. But who were his models? In several instances, it appears as though Vermeer used the same model for multiple pictures. For example, *The Astronomer* (page 52) and *The Geographer* (page 53) were painted at about the same time and likely portray the same man. Some scholars have suggested that Catharina, Maria Thins and several of Vermeer's children may have modeled for him. Vermeer also may have used servants, as imagined in

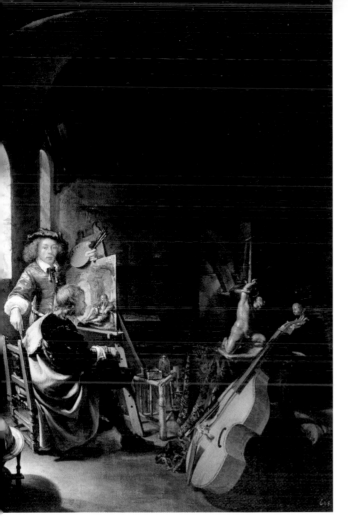

Frans van Mieris' portrayal of a patron visiting an artist's studio illustrates the vital relationship between painter and buyer. Vermeer likely had few patrons during his lifetime.

the book *Girl with a Pearl Earring*, or he may have hired women from outside his household. Unfortunately, none of these speculations can be proven.

Catholic Artist in a Protestant Country

Vermeer's decision to marry into a Catholic family and convert to Catholicism was unusual in a Protestant country at that time. Certain prejudices against Catholics existed in Dutch society. For example, Catholics could not worship openly. They had to hide their chapels within private homes or other secular buildings. Yet Catholics enjoyed considerable freedom in the Netherlands. Many Dutch families had relatives that never left the Catholic faith, and there was a strong reluctance to impose

harsh legal measures against Catholic believers. In the Dutch art world, Catholics seem to have experienced little career-related prejudice. The Guild of St. Luke, for example, included several other Catholics besides Vermeer. Jan's own conversion had a decidedly positive effect on his career. Catharina's family gave him the time and resources he needed to develop his art in creative way. Moreover, many historians believe that the Jesuit community in Delft offered Vermeer significant commissions. One likely commission, the *Allegory of Faith* (page 34), incorporates many elements of Jesuit imagery. These include the open Bible, the devout gaze of the women symbolizing Faith, and the crushed snake representing the victory of religious virtue over sin.

Art Dealer

Like his father, Jan sought to make extra money by dealing in the art market. Vermeer clearly took this job seriously. He developed a good understanding of the value and authenticity of paintings, and he even

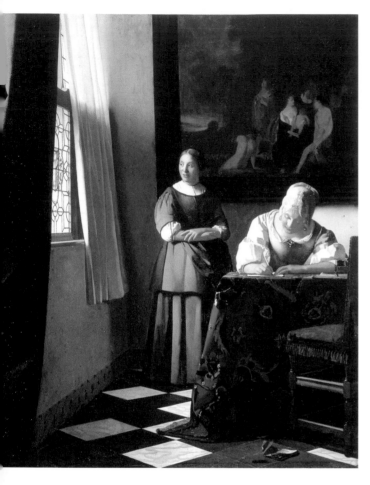

Sunlight floods the room in *A Lady Writing a Letter with Her Maid*, a painting that has the familiar Vermeer trademarks: a young woman with her maid near a window, an allegorical painting on the back wall, and a black-and-white patterned floor.

received an appointment to help appraise art for the royal family of Brandenburg.

Death and Financial Troubles

Though a moderately successful and respected artist, Vermeer never developed a practice that comfortably supported his large family. The artist's financial difficulties increased during the last years of his life. War and economic hardship led to a severe economic downturn that caused prices of art works to collapse. As Catharina Vermeer wrote, "During the long and ruinous war with France, not only could [Vermeer] not sell his work, but in addition, at great loss to himself, the pictures by other masters which he bought and traded were left in his hands."

At the end of his life, the normally reserved, reticent Vermeer was forced to deal aggressively with his family's growing financial problems. In 1675, he was forced to borrow the large sum of 1,000 guilders. His debts soon became onerous enough to seriously affect his health, and the great artist passed away later that year, at the age of only forty-three. He was buried in the tomb of his mother-in-law.

Continuing Financial Crisis for the Family

Both Vermeer's wife and mother-in-law survived Jan, and it fell upon these two women to put the family's finances in order. In 1676, they accepted the appointment of a representative to oversee the resolution of Vermeer's debts. Interestingly, the man chosen for this job was the great scientist Anthony van Leeuwenhoeck. Part of Van Leeuwenhoeck's settlement probably included the sale of the *Art of Painting* (page 40) at an auction in 1677, against the wishes of Maria Thins.

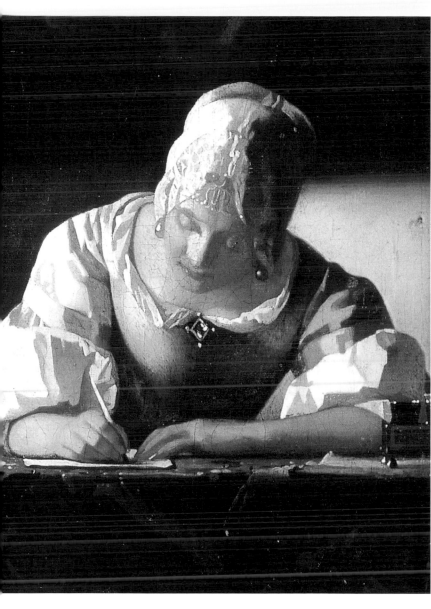

Vermeer's elegant
letter writer is a study
in concentration.

However, Vermeer's family never completely recov-
ered from his death. A few of Vermeer's children
were able to acquire career training. One became a
priest, and another worked as a physician. Before
Vermeer's death, his oldest daughter did manage to
marry into another wealthy Catholic family. Yet
Catharina herself never got out of debt. She was
forced to borrow 300 guilders only a few months be-
fore her death in 1688.

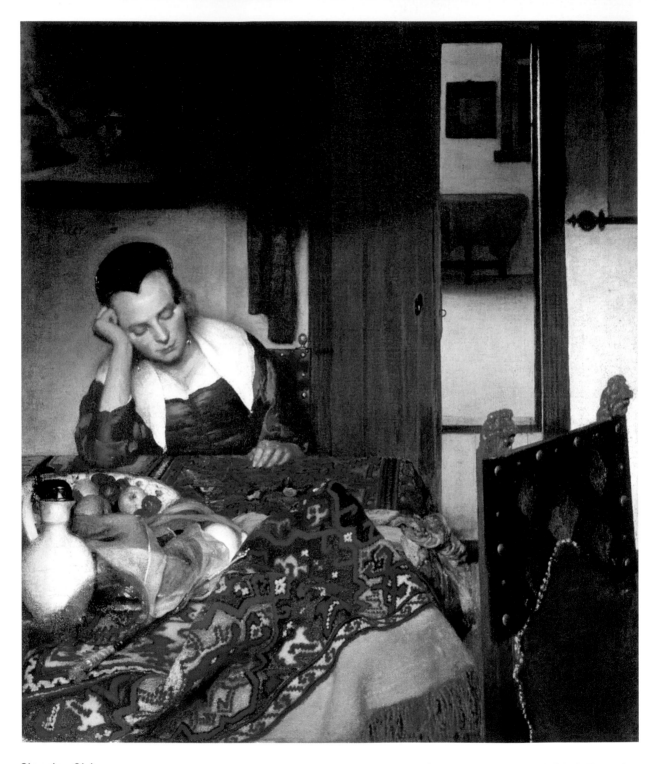

Sleeping Girl In this little scene, the position of the chair and folded tapestry seem to direct the viewer into the room behind the half opened door. Yet Vermeer also makes us notice the elegant bowl of fruit and the lustrous sheen of the girl's clothing.

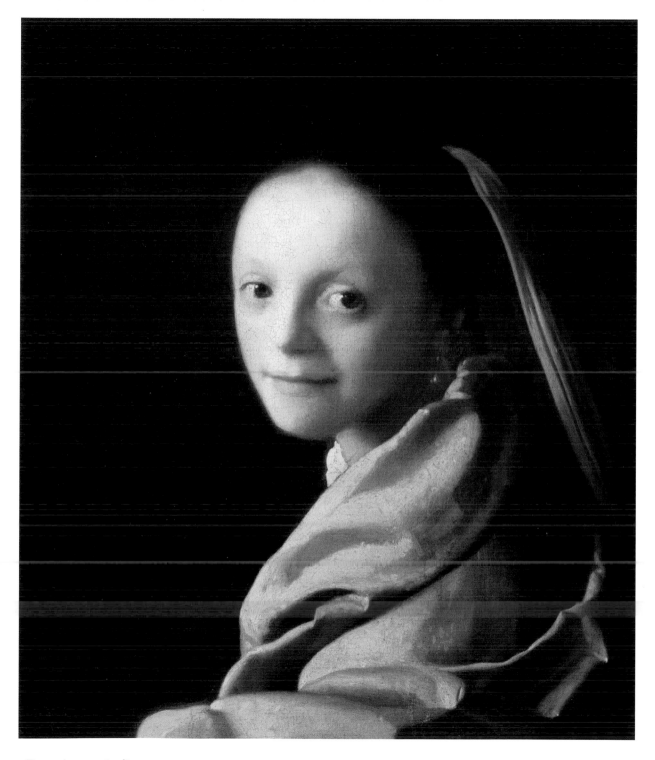

Engaging portrait Like the girl with a pearl earring (page 24), this figure engages the viewer with her intense gaze. Yet her features are somewhat less idealized than those of Vermeer's more famous young woman, and her clothing is less dramatic.

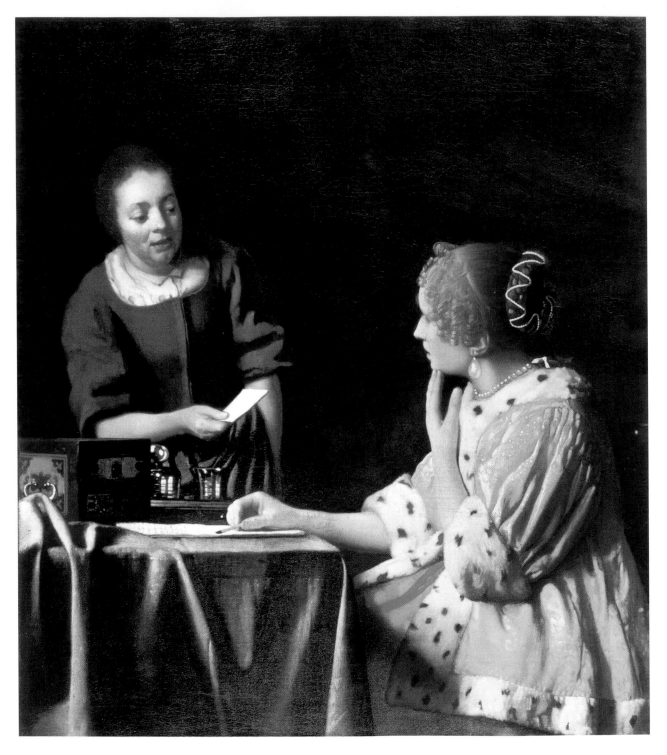

Mistress and Maid Vermeer painted several works that explore the relationships between well-to-do women and their female servants. These paintings always involve letters or letter writing.

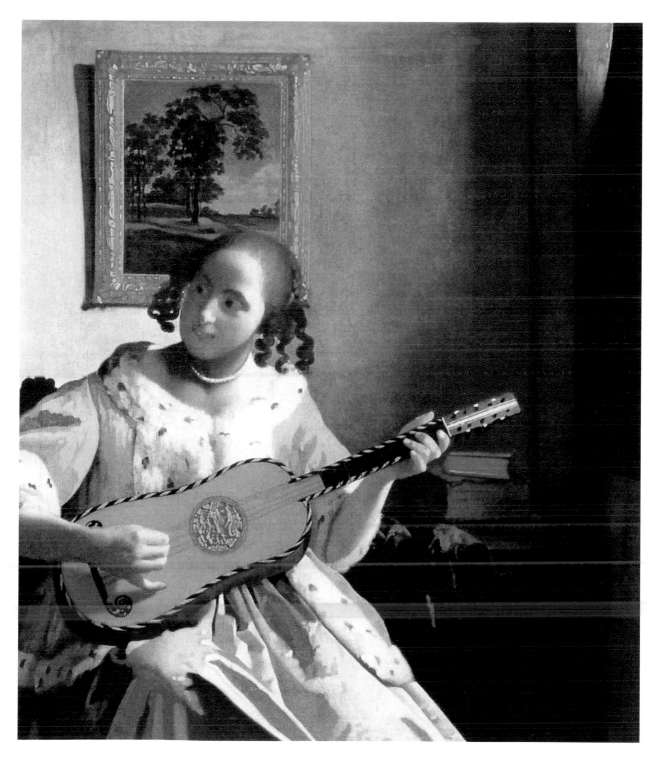

The Guitar Player The fur-lined yellow jacket again makes its appearance in this light-hearted work. The face of the guitar player, one of Vermeer's most abstract treatments, has an almost perfectly oval shape. Similar abstractions occur in other late paintings by the artist.

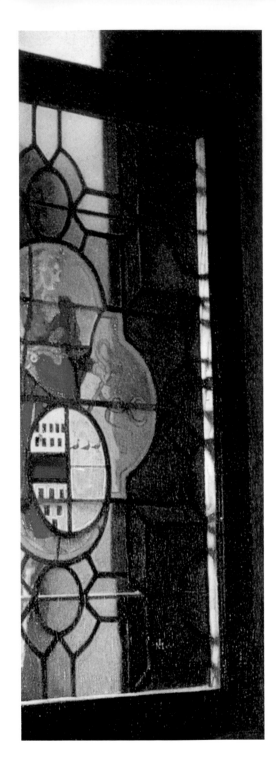

Composition in glass Because of his keen interest in the effects of light, Vermeer often features windows prominently in his works. This finely detailed stained glass window from *The Girl with the Wine Glass* (opposite) also appears in *The Glass of Wine* (page 16).

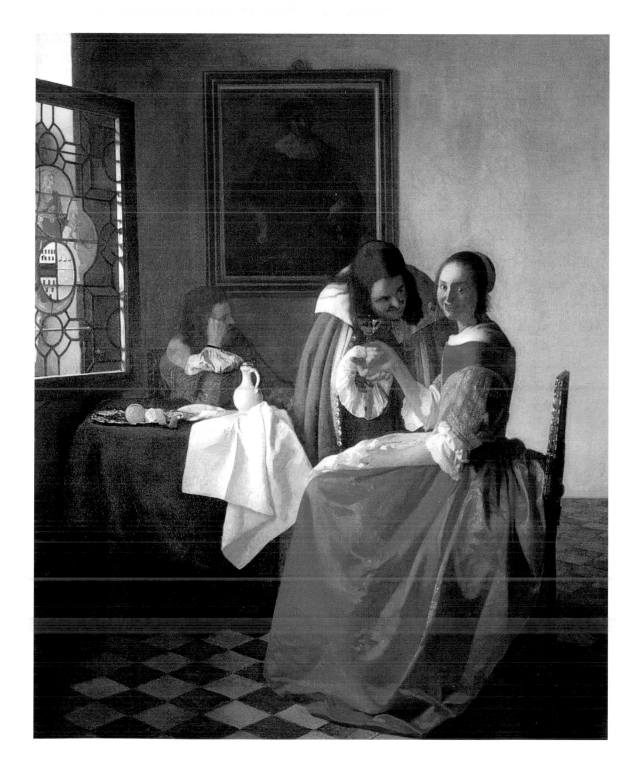

Aggressive suitors Many scholars interpret *The Girl with the Wine Glass* as a competition for the young woman's affections. Clearly, the man in the chair seems dejected compared with the man raising the woman's hand. Yet the winning suitor's overly eager gaze—and the girl's awkward expression—indicates that Vermeer may be criticizing the behavior in this scene as immoral.

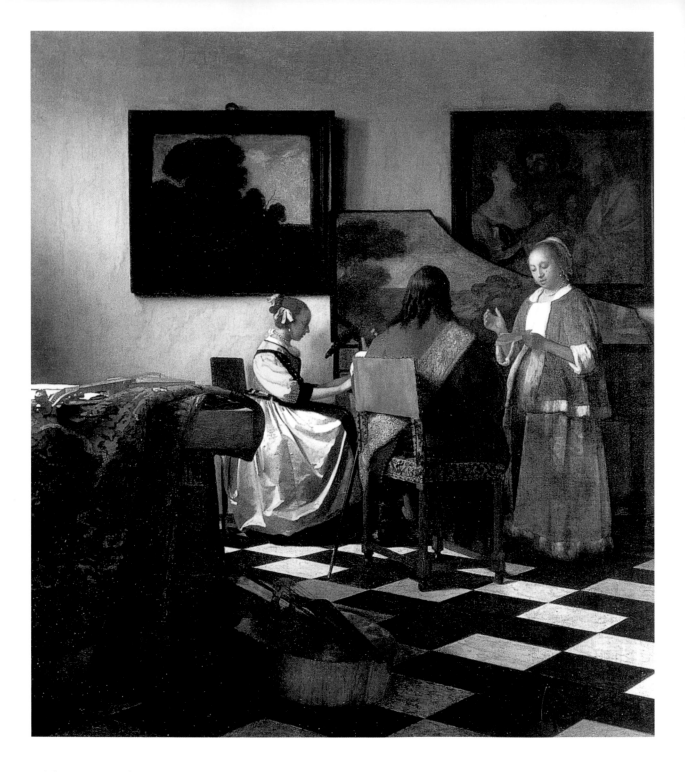

A lost masterpiece For many years this painting, known as *The Concert*, hung in Boston's Isabella Stewart Gardiner Museum. Sadly, art thieves stole the painting in 1990, and it has not yet been recovered.

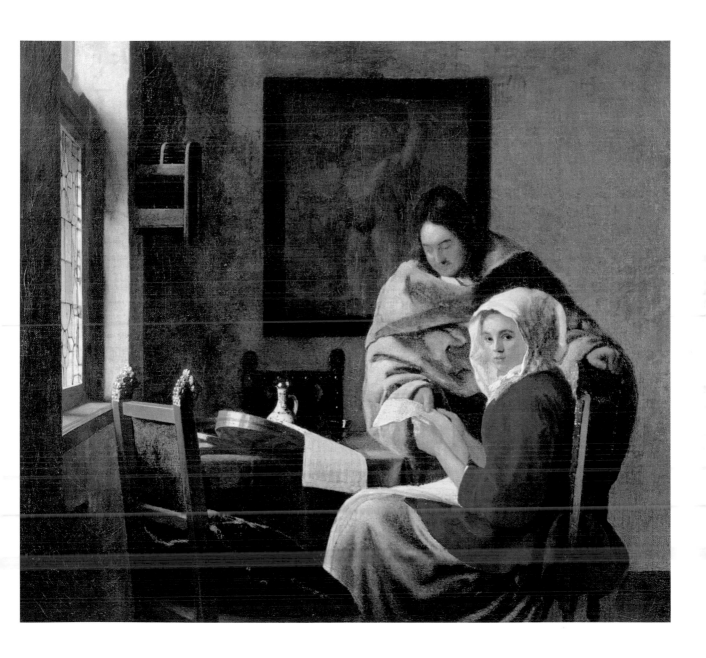

A distracted couple In *Girl Interrupted at Her Music*, the young woman's startled face indicates that she has been momentarily disturbed by the viewer. This expression differs from that of other Vermeer women, who treat the viewer's attention in a more welcoming manner.

Love

"... he who lives under the guidance of reason will endeavor to repay hatred with love."

Baruch Spinoza
(1632–1677),
The Ethics

A devotion to family …

… characterized the soft-spoken Vermeer. Jan dearly loved his wife Catharina and even developed a strong relationship with his mother-in-law. The only other women in his life were the beautiful figures he created on his canvases.

Schipluiden

Vermeer and Catharina married in the Jesuit church of Schipluiden, a small village just outside of Delft. Catholics had a strong presence in this town, and they could worship there openly. The couple married on the 20 April, 1653. Vermeer's oldest daughter also married in this church.

Vermeer's family …

-→ …included seven girls and three boys. Historians do not know the sex of the eleventh child.
Like most women of the 17th century, Catharina suffered the loss of several babies in childbirth.

Modest Living

Vermeer's interior scenes sometimes depict the meeting of men and women with a certain modesty and reserve. Typical of these works is *Officer and a Laughing Girl* (page 93), where the woman has a friendly, yet vaguely self-conscious expression on her face. Here are two people observing the strict rules of etiquette governing the relations between unmarried men and women.

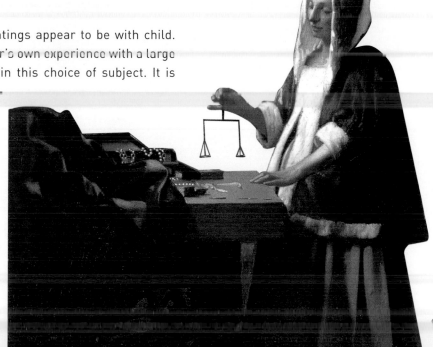

Vermeer and Pregnancy

Many women in Vermeer's paintings appear to be with child. Scholars speculate that Vermeer's own experience with a large family may have played a role in this choice of subject. It is known that Catharina's deranged brother Willem beat her during one or more of her pregnancies. Romantics may interpret the stoic, graceful women in Vermeer's paintings as tributes to the fortitude and courage of his real-life wife.

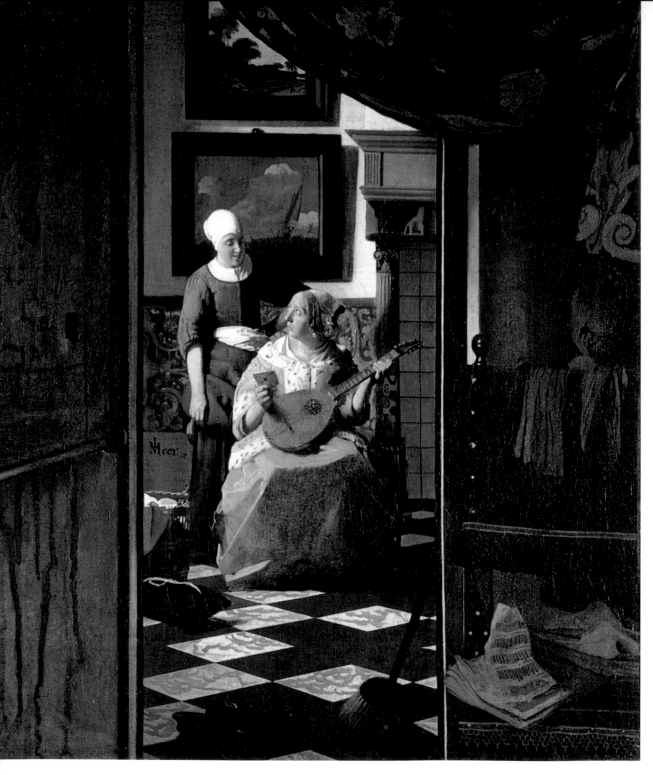

In *The Love Letter*, Vermeer enables the viewer to peek discreetly into a scene in which the young lady is discussing a love letter with her servant. Jan and Catharina probably wrote such letters to each other during their courtship.

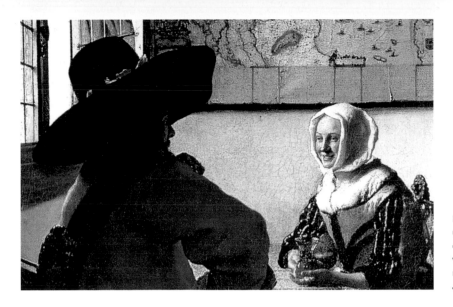

In Dutch society of the 1600s, unmarried men and women observed strict rules of etiquette when meeting. Such prescribed restraint is apparent in *Officer and a Laughing Girl*.

Jan and Catharina

"As concerning marriage, it is certain that this is in harmony with reason, if ... the love of both, to wit, of the man and of the woman, is not caused by bodily beauty only, but also by freedom of soul."

Baruch Spinoza, *The Ethics*

Marriage and Conversion

When compared with the tumultuous romantic lives of many artists, Vermeer's love life seems to have been a rather simple one. He was deeply devoted to his wife, Catharina. Jan's marriage was, in many ways, the single most important event of his life. Catharina not only provided Jan with a good companion and friend, but her family promoted him socially in the Delft community. Without Catharina and Maria Thins, Vermeer may not have found the resources to develop his art successfully.

A Powerful Mother-in-Law

Historical records indicate that, just before Vermeer's marriage took place, Maria Thins made an interesting admission. She stated that she was not in favor of the

Jan Vermeer's signature appears in different forms on different paintings. In *The Love Letter* (page 92), Vermeer places the initial of his first name over a shortened form of his surname (right). Jan and Catharina's signatures appear together on a small number of surviving documents.

marriage, yet she would not oppose it. Because Jan was still Protestant at that time, Maria probably could not support the match openly without running foul of the Catholic authorities. Yet Catharina's mother knew that Jan was just about to convert. By the time Vermeer and Catharina married, Jan was officially Catholic.

Unfortunately, Maria Thins experienced difficulties with many other men in her life. Her husband, Reynier Bolnes, verbally and physically abused her, and she was forced to obtain a formal separation from him in 1641. Maria's son Willem also developed an abusive personality. He not only beat his mother but also struck Catharina. In 1666, Maria committed Willem into a local house of correction. With this difficult family history, Maria must have been happy to welcome the gentle Jan into her household.

A Family of Women

Fate would have it that most of Vermeer's children were girls. Of the eleven children that survived the artist's death, ten are known. Seven of them, including the six eldest, were girls and three were boys.

The close bond Jan and Catharina enjoyed seemed to rub off on at least one of their children, the eldest daughter, Maria (c. 1654–c. 1713). She was the one child who married during Vermeer's lifetime. Maria's

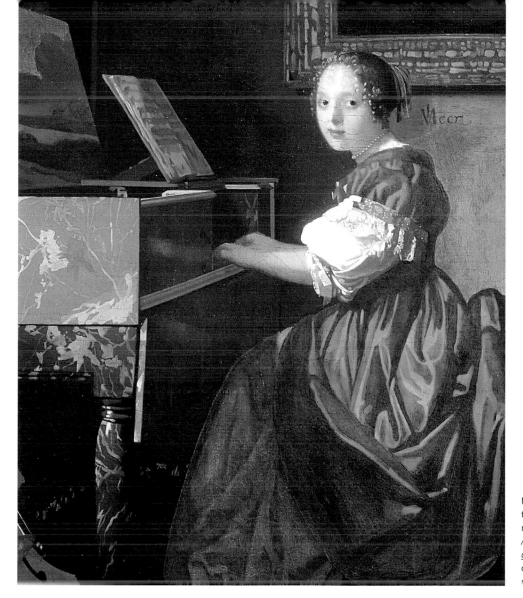

Music is an important theme in many of Vermeer's images, including *A Lady Seated at the Virginal*. The women in Jan's own family probably played musical instruments.

husband, Johannes Cramer, was a wealthy dealer in silk and was also Catholic. The couple's wedding took place in Schipluiden in 1674.

Who Was the Girl with the Pearl Earring?

The beauty of Vermeer's *Girl with a Pearl Earring* (page 24) has inspired many historians and writers to speculate on who the sitter might have been. Some have argued that the sitter was Vermeer's daughter Maria, who was born about 1654. She would have been around the right age at the time the painting was completed. Others have suggested that the sitter was Magdalena van Ruijven (1655–1682), daughter of Vermeer's probable client, Pieter van Ruijven. Author Tracy Chevalier, in her novel *Girl with a Pearl Earring*, created a fictional maid who modeled the earring for Vermeer.

Yet we probably will never know the identity of this famous young girl. In fact, many historians believe that the painting is not a real portrait at all, but an idealized image meant to represent beauty or purity.

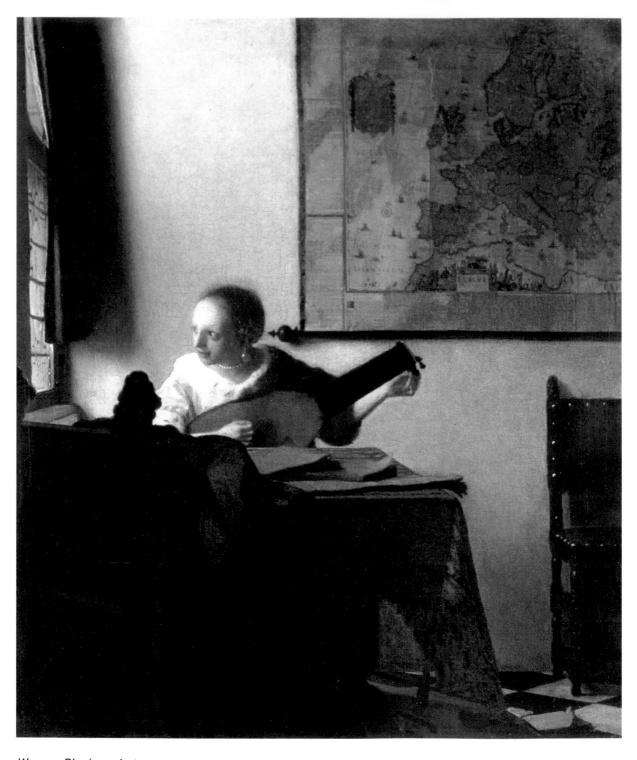

Woman Playing a Lute The attention of Vermeer's lute player has been drawn away from her instrument and toward someone or something outside her window. Her intensely curious gaze lends animation and mystery to the otherwise quiet scene.

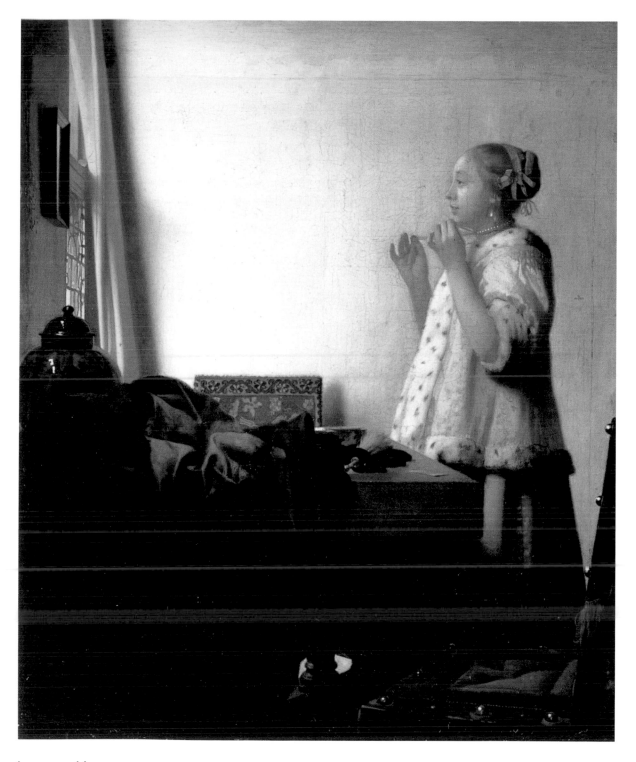

A new necklace Vermeer's talent for portraying complex human expressions gives emotional depth to his *Young Woman with a Pearl Necklace*. As the girl looks at herself in the mirror, her face and posture indicate both restrained joy and introspective self-reflection.

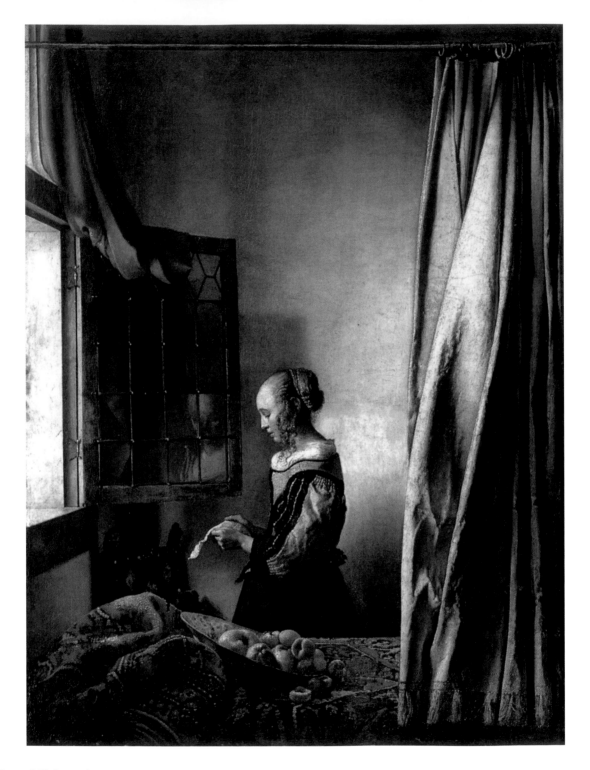

Thoughtful reader This early work of Vermeer, painted in the late 1650s, was possibly the first to combine the opened window and reflective female subject. The painting also includes a beautiful still-life composition in the foreground, featuring the delicately patterned tapestry and fruit-filled bowl.

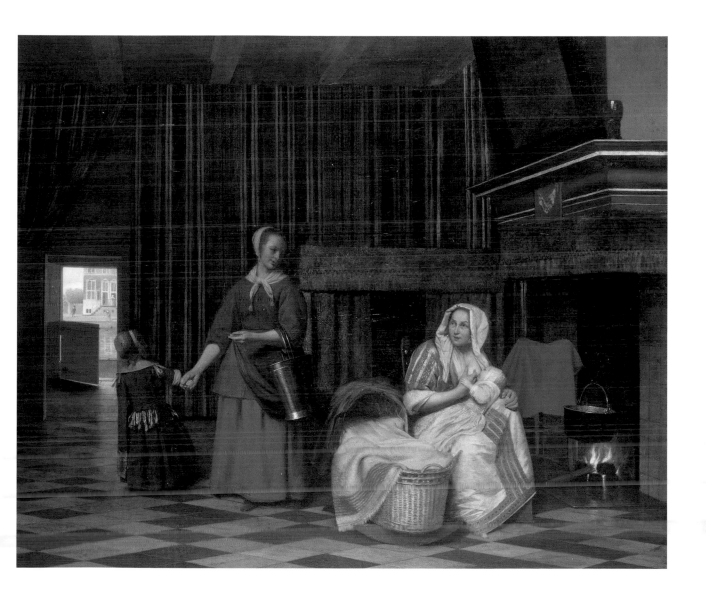

Interior and exterior Vermeer's contemporary Pieter de Hooch often painted intimate domestic scenes within complex spatial settings. This image, known as *Suckling Mother and Maid*, draws the viewer away from the nursing mother and toward the sunlit street and canal outside the partially opened door.

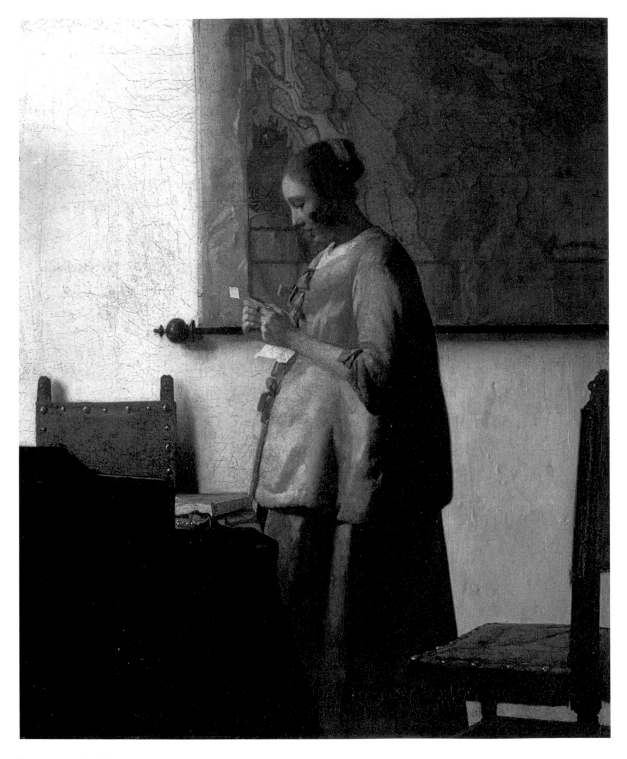

The woman in blue This famous painting resembles the earlier *Girl Reading a Letter at an Open Window* (page 98). Yet its composition is less cluttered, enabling the viewer to focus more directly on the young woman's meditative face. Some scholars believe that this woman is pregnant.

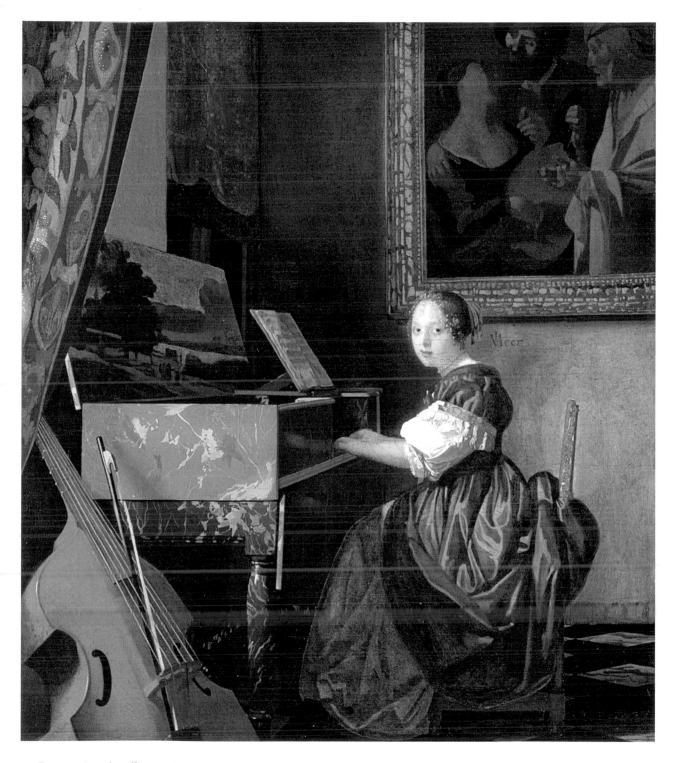

Expressive details One of Vermeer's last canvases, *A Lady Seated at the Virginal* (ca. 1670–1675), features a boldly painted keyboard instrument. The artist uses quick, abstract brushwork to give the side of the instrument the appearance of marble.

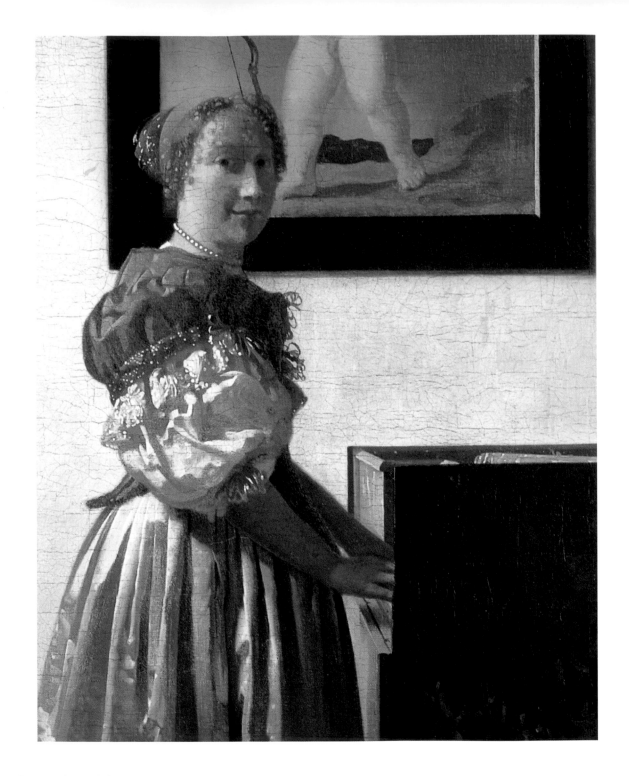

A casual musician Like the lady seated at the virginal (page 101), this standing woman plays an instrument that is decorated with bold marble patterns. Other details, including the woman's hair and the frills on her clothing, are painted with similarly free brushwork characteristic of Vermeer's late style.

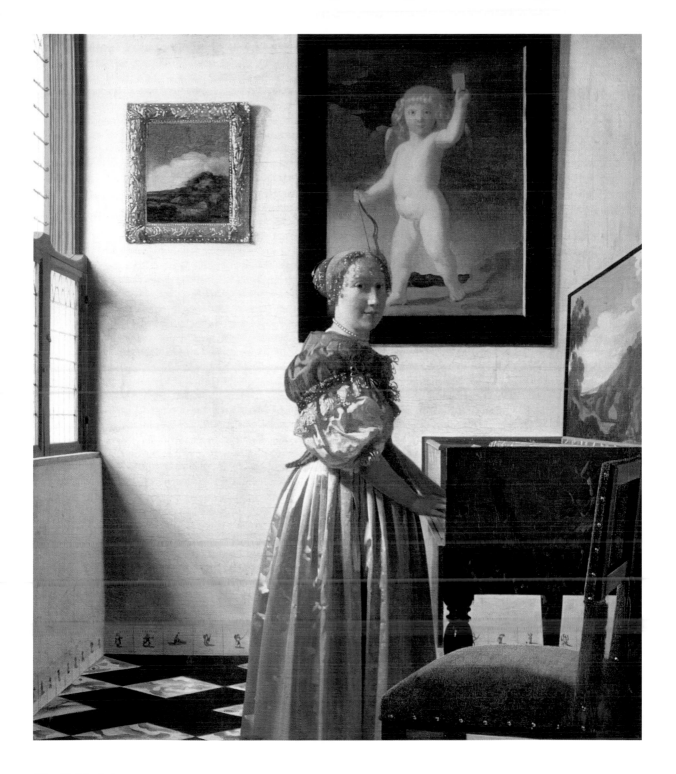

The light of day In *A Lady Standing at the Virginal*, sunlight floods the room and energizes what might otherwise be a static composition. Vermeer places a painting of Cupid prominently on the back wall behind the woman's face. The meaning of this somewhat humorous image is unclear, although it might indicate that the woman's gaze toward the viewer is an affectionate one.

Vermeer Today

"The power and beauty of Vermeer's *Girl with a Pearl Earring* is that in such a seemingly simple painting he has extended a moment so that we think about her long after we've stopped looking at her. She contains much more in her face than one single moment of time."

Tracy Chevalier

Modern Fame

The popularity of Vermeer has grown continuously since the French art historian Étienne-Joseph Théophile Thoré (1807–1869) wrote the first important biography of the painter. Vermeer has inspired the work of authors, filmmakers, and many famous artists. His paintings have also been linked to controversy and scandal. In short, the modest man of Delft has finally achieved his international celebrity.

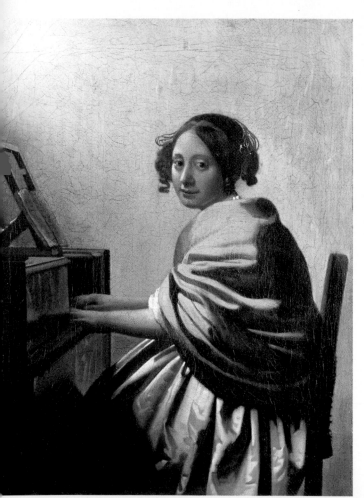

Priceless Legacy

In 2004, a painting entitled *Young Woman Seated at the Virginal* (left) came to auction in London. For many years the painting was considered a fake. Despite the controversy over its attribu-tion, the auction advertised it as the first Vermeer to be sold publicly in 80 years. The painting sold for the staggering price of £16 million, or about $30 mil-lion. After the auction, Alexander Bell of Sothe-by's stated, "It is unlikely that a painting by Ver-meer will ever come to the market again."

Young woman at a virginal:
was she worth $30 million
(£16 million)?

Vermeer Scholarship

The explosion of interest in Vermeer has led to extensive studies of the author's work. Modern imaging technology has allowed scholars to analyze how the painter created his works and what elements of the painting he altered during the course of production. Art restorers continue to learn more about Vermeer's working methods. In 1994, the restoration of *Girl with a Pearl Earring* (page 24) found that the painter added a greenish glaze to the black background. This glaze consisted of the colors indigo and weld, a yellow dye.

Continuing Inspiration

Vermeer was almost certainly a lover of fine music, as musical instruments play a prominent role in so many of his works. One famous classical music ensemble paid direct tribute to the artist. The Vermeer String Quartet, founded in 1969, proudly carried the artist's name until it disbanded in 2007.

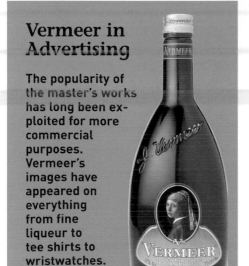

Vermeer in Advertising

The popularity of the master's works has long been exploited for more commercial purposes. Vermeer's images have appeared on everything from fine liqueur to tee shirts to wristwatches.

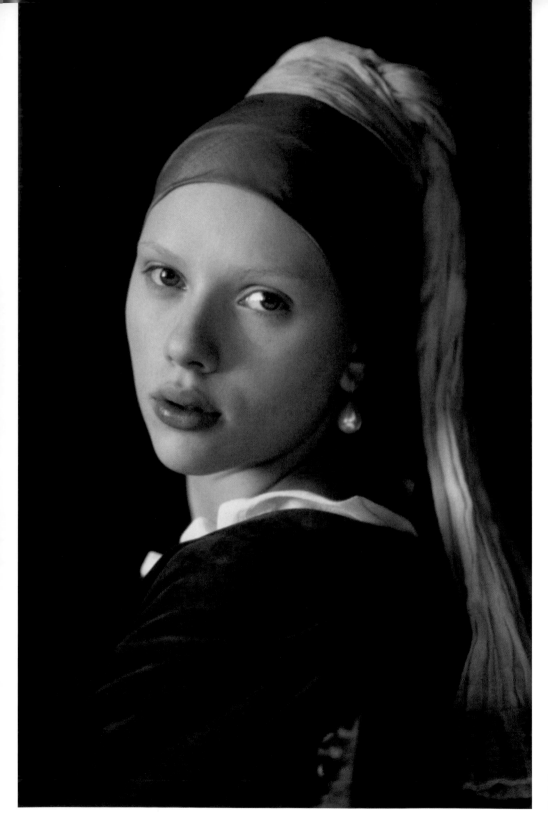

Scarlett Johansson as
Griet in the film *The Girl
with the Pear Earring.*

Vermeer's paintings continue to fascinate museum goers today. The Mauritshuis museum in The Hague has one of the finest collections of Vermeers, including *Girl With the Pearl Earring.*

The Rebirth of Vermeer

"But, an art critic having written somewhere that in *Vermeer's View of Delft* ... a little patch of yellow wall ... was so well painted that it was, if one looked at it by itself, like some priceless specimen of Chinese art, of a beauty that was sufficient in itself ..."

Marcel Proust (1871–1922) from his novel
A la recherche du temps perdu

Early Legacy: Years of Obscurity

The family of Pieter van Ruijven amassed the largest collection of Vermeer paintings after the artist's death. In 1696, this collection was sold in an auction that also included paintings from other estates. Vermeer's work would soon make its way into different collections over the course of the next 150 years. These paintings would elicit praise from collectors and dealers throughout the 18th and early 19th centuries. Even King George III of Great Britain (1738–1820) purchased a Vermeer, *The Music Lesson* (page 61) in 1762. The canvas still resides in the collection of the British crown.

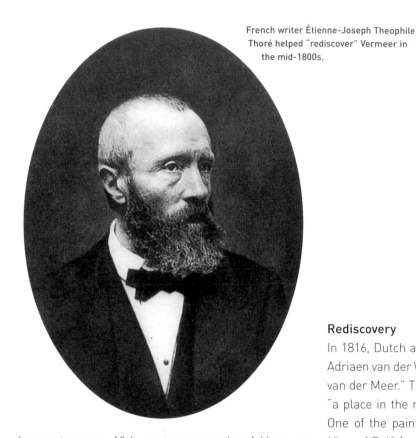

French writer Étienne-Joseph Theophile Thoré helped "rediscover" Vermeer in the mid-1800s.

In most cases, 18th-century records of Vermeer paintings attribute these works to other Dutch artists. King George's Vermeer was sold as a work by Franz van Mieris (1635–1681). The *Girl Reading a Letter at an Open Window* (page 98) was attributed to Rembrandt in a sale of 1742. The *Art of Painting* (page 40) was sold in 1813 as a work by Pieter De Hooch. Yet the name of Vermeer never completely died out. The famous English painter Sir Joshua Reynolds (1732–1792) referred to *The Milkmaid* in 1781 as "A woman pouring milk from one vessel to another: by D. Vandermeere."

Rediscovery

In 1816, Dutch art historians Roeland van Eynden and Adriaen van der Willigen published a work on the "Delft van der Meer." They considered his paintings worthy of "a place in the most distinguished collections of art." One of the paintings they attributed to Vermeer was *View of Delft* (pages 64–65), which they knew by reputation but had never seen in person. Then in 1822, the great painting reappeared in an auction in Amsterdam. The government of the Netherlands purchased the work for the large sum of 2,900 guilders. Dutch King William I then insisted the painting be placed in his royal collections at the Mauritshuis in The Hague.

This event signaled the beginning of Vermeer's contemporary fame. The French art historian Étienne-Joseph Théophile Thoré developed a great admiration for the *View of Delft*, and he decided to conduct extensive research on the painting's mysterious author. The results

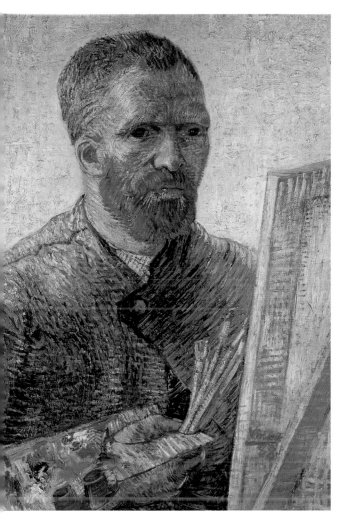

Vincent van Gogh was one of many 19th-century artists who became fascinated with Vermeer's paintings.

important art movements owed much to Vermeer: the Realist movement sought to portray ordinary people realistically, while the Impressionists devoted much of their focus to the study of light.

Even Vincent van Gogh (1853–1890), Holland's greatest nineteenth century artist, was fascinated by Vermeer. Van Gogh commented in 1888 on the sophisticated color scheme of the *Woman in Blue Reading a Letter* (page 100) when he wrote: "The palette of this strange artist comprises blue, lemon-yellow, pearl-gray, black and white. It is true that in the few pictures he painted one can find the whole gamut of colors. But the combination of lemon yellow, a dull blue and a light gray is as characteristic of him as the harmony of black, white and pink is of Velázquez."

of his efforts appeared in several articles published in the 1860s in the French periodical *Gazette des Beaux-Arts*. Thoré's articles proved to be the first scholarly treatment of Vermeer, and they inspired a history of Vermeer scholarship that continues to the present day. The "Sphinx of Delft," as Thoré dubbed Vermeer, had been elevated to the status of a great master.

Vermeer and 19th-Century Art

In many ways, the 19th century proved a perfect era for Vermeer's rediscovery. Two of the century's most

Growing International Tributes

By the turn of the 20th century, Vermeer had become an internationally popular artist. A number of collec-

This roof detail from Vermeer's *View of Delft* (pages 64–65) shows his virtuoso handling of color and light.

tors in Europe and the United States began snatching up Vermeers at increasingly high prices. American philanthropist Henry G. Marquand (1819–1902) purchased *Young Woman with a Water Pitcher* (page 51) and then donated the painting to the New York's Metropolitan Museum of Art in 1889. Shortly afterward, American heiress Isabella Stewart Gardner (1840–1924) purchased *The Concert*, which became a mainstay in her famous museum in Boston. Even the great American financier J. Pierpont Morgan, Sr., (1837–1913) developed a taste for Vermeer's work. His purchase, *A Lady Writing*, eventually made its way to the National Gallery of Art in Washington, D.C.

Vermeer and Dalí

Among 20th-century artists, the Spanish surrealist Salvador Dalí (1904–1989) may have had the most affection for Vermeer. His 1934 painting *The Ghost of Vermeer of Delft Which Can Be Used As a Table* (page 117) features the artist from the back in wildly elongated form. It seems to echo the figure of the painter

from the *Art of Painting* (page 40). Dalí also created his own version of the *Lacemaker* (page 48) in 1955.

Famous Forger

Other painters of the early 20th century gave tribute to Vermeer in less positive ways. Some of the most famous art forgeries of this era revolved around Vermeer. The leading Vermeer forger was Dutch artist Hans van Meegeren (1889–1947). Van Meegeren had established a successful painting career in the 1910s and 1920s, using a style resembling those of the Old Masters. In the late twenties, however, art critics began dismissing his work as unoriginal, too reliant on earlier works. Angered at the negative responses, Van Meegeren decided to attempt a "perfect" forgery. He carefully studied the methods and materials of the Dutch 17th-century masters, including Vermeer.

During the 1930s, Van Meegeren produced several paintings that he was able to sell as authentic Vermeers. Perhaps Van Meegeren's most famous work, however, was *Christ at Emmaus*, which mimics

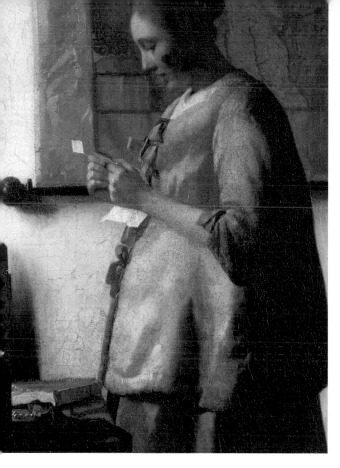

Dutch artist Vincent van Gogh was
fascinated by the color composition
of *Woman in Blue* (page 100).

Vermeer's early religious work. This painting was pur-
chased in 1937 for the then huge sum of 550,000
guilders. Van Meegeren's paintings even wound up in
the collection of German Nazi leader and art lover Her-
mann Göring (1893–1946). Göring had acquired the
painting *Christ with the Adulteress*, another Vermeer
knock-off, from the banker and art dealer Aloes Niedl.

Arrest and Death

In total, Van Meegeren made the equivalent of mil-
lions of dollars selling these fake works, money he
used to buy over 50 estates for himself. However,
Christ with the Adulteress proved to be the beginning
of his downfall. The painting was seized by Allied
forces at the end of the war. The ownership of the
painting was traced to Niedl, who told authorities
that he had purchased the work from Van Meegeren.
Van Meegeren had earlier been arrested as a pos-
sible Nazi collaborator and was questioned about
Niedl's testimony. Possibly to avoid a harsh sentence,
the forger admitted that the he painted the fake
Vermeer.

Van Meegeren's admission led to the discovery of the
artist's other forgeries in 1947. The Dutch police
found Van Meegeren guilty of fraud and sentenced
him to prison, but the artist suffered a heart attack
and died before he could serve time.

Today, art historians find it difficult to believe that
these and other Vermeer fakes could have been
passed off as genuine. Vermeer's fame, which has
continued to grow since World War II, has made re-
productions of his works far more available than ever
before. Our greater exposure to—and knowledge of—
Vermeer makes these paintings look far less authen-
tic than they did in the 1930s.

An Unsolved Crime

The growing popularity of Vermeer led to another fa-
mous crime. In 1990, thieves broke into the Isabella

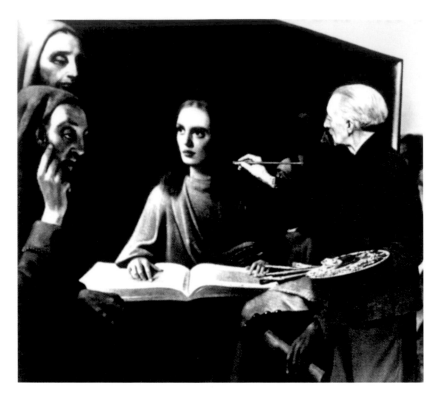

Stewart Gardner museum in Boston and stole several paintings, including Vermeer's *The Concert* (page 86). Authorities believe the crime was committed by people with inside knowledge of the museum, which at the time had relatively lax security.

Sadly, this painting has never been recovered, despite a reward that has reached $10 million dollars, the largest ever for stolen art. Today, the Gardner museum still retains an open space on the wall on which the Vermeer masterpiece originally hung.

A Unique Exhibition

Despite the risks of theft and damage that can occur in all famous and delicate works of art, a unique exhibition of Vermeer took place in 1995 and 1996. This exhibition, entitled simply *Johannes Vermeer*, brought together twenty-one of the artists paintings, the largest

ever assembled since the sale of 1696. These works included the *View of Delft* and *Girl with a Pearl Earring*. The exhibition was shown at the National Gallery of Art in Washington, D.C., and at the Royal Cabinet of Paintings at the Mauritshuis in The Hague. During the run at the National Gallery, the U.S. government was experiencing temporary furloughs, or shutdowns, caused by its inability to finalize a federal budget. Though these furloughs reduced by nineteen days the full run of the exhibit, private funds were raised to keep the museum open during much of the government shutdown. Amassing a similar Vermeer exhibit in the future, especially in the post-9/11 world, may prove all but impossible.

Vermeer in Literature and Film

Vermeer has not only inspired the creative energies of modern painters, but he has also influenced writers and filmmakers. One of the most famous Vermeer-inspired books, *Girl with a Pearl Earring*, was

The remarkable Vermeer exhibition of 1995–1996 drew long queues at the National Gallery of Art in Washington, D.C.

published in 1998 by American Tracy Chevalier. This best-selling work explored a fictional account of Vermeer's private life, in which a family maid called Griet served as Vermeer's muse and modeled for his famous painting. The book presented the character of Pieter Van Ruijven as a lecherous patron, who made sexual advanced towards the young Griet.

The popularity of Chevalier's book led to the making of a feature film in 2003 based on the story. Scarlett Johansson played the role of Griet and Colin Firth portrayed Vermeer. Like the book, the film became a popular and critical success. However, certain art historians chastised some of the liberties taken by the story. They argued that the events in the film present a distorted picture of the artist's personal life, and they felt that Catharina Vermeer was portrayed too negatively.

Despite the differing opinions of scholars and artists, worldwide fascination with Vermeer continues to grow. The "Sphinx of Delft" remains one of the most captivating figures in the history of art.

The Image Disappears Salvador Dalí paid homage to Vermeer in this 1938 optical illusion. Viewed one way, the painting depicts a Vermeer-like interior scene with a woman, map and drawn curtain. Viewed another way, the scene becomes a large bearded head.

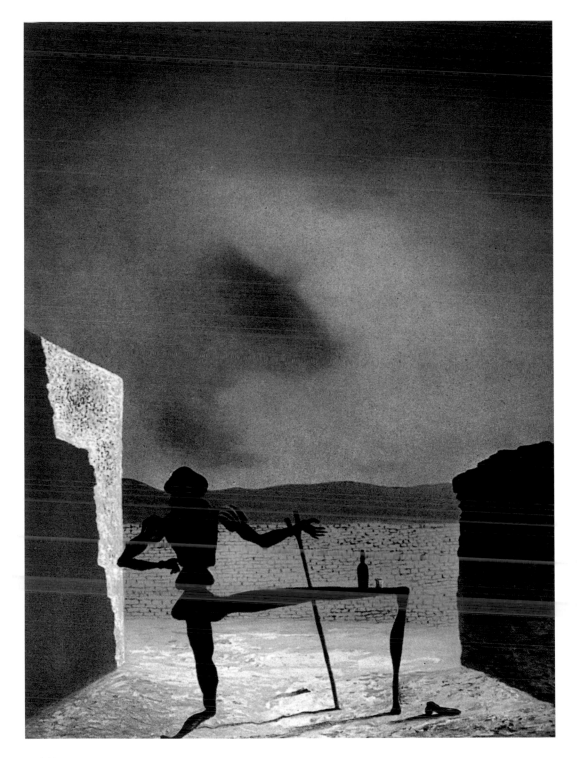

A surreal Vermeer In his *The Ghost of Vermeer of Delft Which Can Be Used As a Table* from 1934, Dalí depicts an elongated figure that somewhat resembles the artist in Vermeer's *Art of Painting* (page 40).

A fake supper Hans van Meegeren's *Christ at Emmaus* may be the best known of all his Vermeer fakes. This work attempts to mimic the Delft master's early religious work, including *Christ in the House of Mary and Martha* (page 33). Yet van Meegeren's image lacks the subtlety of Vermeer's modeling, color scheme, and character portrayals.

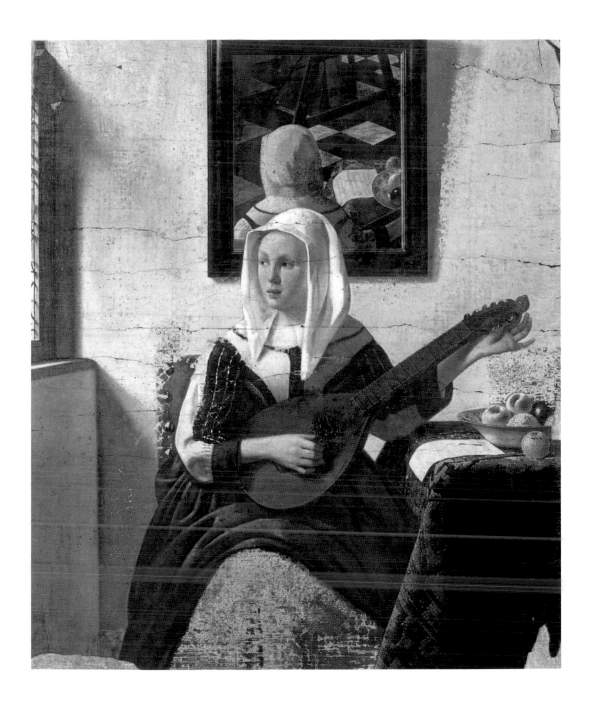

Out of tune Another van Meegeren forgery, *Woman Making Music* (1935), is based on Vermeer's *Woman Playing a Lute* (page 96). This painting too falls short of Jan's high standards. Such canvases may have fooled people in the 1930s, but they could not be mistaken for true Vermeers today.

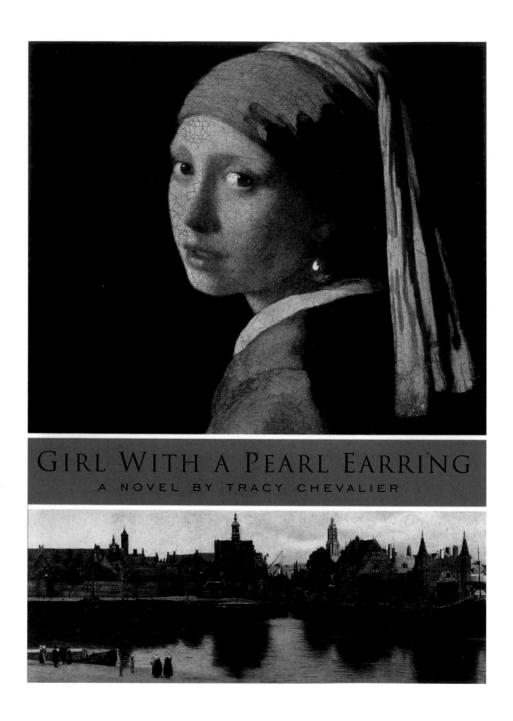

GIRL WITH A PEARL EARRING
A NOVEL BY TRACY CHEVALIER

Vermeer and stardom The fame of Vermeer's work has inspired a number of popular books. The most famous of these, *The Girl with a Pearl Earring*, was made into a popular feature film starring Colin Firth as Vermeer and Scarlett Johansson as Griet, his fictional model.

A lesson in color Colin Firth's Vermeer shows Griet how to mix different paints. The techniques of the old masters have long fascinated modern artists and scholars.

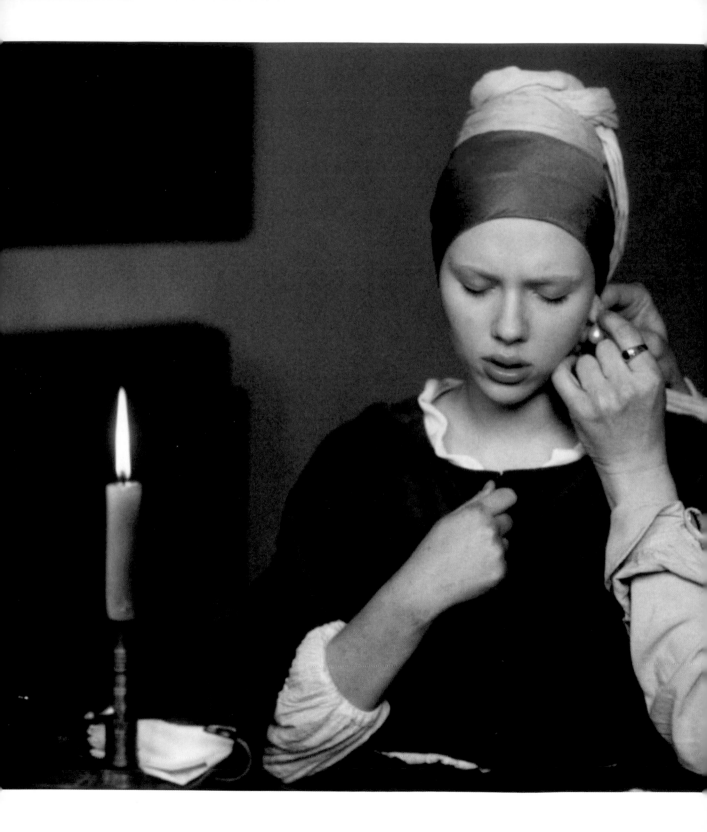

I'm ready for my close-up! Vermeer prepares Griet as the "real life" girl with a pearl earring. Though many people have speculated on the true identity of Vermeer's sitters, no clear answers have emerged.

Picture list

p. 5: Abraham Rademaker, *View of Delft with the Schiedamer Gate and Rotterdamer Gate*, Stedelijk Museum Het Prinsenhof, Delft.

p. 6 left: Gerard Houckgeest, *Ambulatory of the Nieuwe Kerk in Delft with the Tomb of William I*, c. 1651, oil on panel, 56 x 38 cm, Royal Picture Gallery, Mauritshuis, The Hague.

p. 6. right: Interior view of the Amstelkring in Amsterdam, 1663 (current state). Photograph.

p. 7 top: Frederik Frytom, Delftware with landscape, c. 1690, faience, 34.6 cm x 34.2 cm, Huis Doorn, Doorn.

p. 7 bottom: Workshop of François Spiering, *Cephalos and Prokris*, c. 1610, wool and silk, 345 x 520 cm, Rijksmuseum, Amsterdam.

p. 8: Willem van de Velde, *De Gouden Leeuw on the river IJ Near Amsterdam*, 1686, oil on canvas, 179.5 x 316 cm, History Museum Amsterdam.

p. 9: Pieter Jansz. Saenredam, *Amsterdam's Old Town Hall*, 1657, oil on panel, 64.5 x 83 cm, Rijksmuseum, Amsterdam.

p. 10: Jacob van Ruisdael, *Grand View of Haarlem*, c. 1670–1675, oil on canvas, 62.2 x 55.2 cm, Kunsthaus, Zurich.

p. 11: Frans Hals, *Married Couple in a Garden (Isaak Massa and Beatrix van der Laen?)*, c. 1622, oil on canvas, 140 x 166.5 cm, Rijksmuseum, Amsterdam.

p. 12: Jan Steen, *The Burgomaster of Delft and His Daughter*, 1655, oil on canvas, 82.5 x 68.5 cm, Rijksmuseum, Amsterdam.

p. 13: Rembrandt van Rijn, *A Painter in His Studio*, c. 1629, oil on panel, 25.1 x 31.9 cm, The Museum of Fine Arts, Boston.

p. 14: Emanuel de Witte, *A Sermon in the Oude Kerk in Delft*, c. 1651/52, oil on panel, 73.2 x 59.5 cm, The National Gallery of Art, Ottawa.

p. 15: Frans Hals, *The Regents of Haarlem's Old Men's Almshouse*, 1664, oil on panel, 172.5 x 256 cm, Frans Hals Museum, Haarlem.

p. 16: Jan Vermeer, *The Glass of Wine*, c. 1658–1660, oil on canvas, 65 x 77 cm, Berlin State Museums, Gemäldegalerie, Berlin.

p. 17: Jan Vermeer, *Soldier and a Laughing Girl*, c. 1658–1660, oil on canvas, 50.5 x 46 cm, The Frick Collection, New York.

p. 18: Jan Steen, *Skittle Players Outside an Inn*, c. 1663, oil on panel, 33.5 x 27 cm, The National Gallery, London.

p. 19: Jan Steen, *St. Nicholas' Day*, c. 1665–1668, oil on canvas, 82 x 70.5 cm, Rijksmuseum, Amsterdam.

p. 21: Jan Vermeer, *Woman Reading a Letter*, c. 1663/64, oil on canvas, 46.6 x 39.1 cm, Rijksmuseum, Amsterdam.

p. 22: Carel Fabritius, *A View of Delft, with a Musical Instrument Seller's Stall*, 1652, oil on canvas on panel, 15.5 x 31.7 cm, National Gallery, London.

p. 23: Carel Fabritius, *Goldfinch*, 1654, Royal Picture Gallery, Mauritshuis, The Hague.

p. 24: Jan Vermeer, *Girl with a Pearl Earring*, c. 1665, oil on canvas, 44.5 x 39 cm, Royal Picture Gallery, Mauritshuis, The Hague.

p. 25: detail, see p. 24.

p. 26: Egbert van der Poel, *The Gunpowder Explosion in Delft on 12 October 1654*, 1654, oil on panel, 37 x 49.5 cm, The National Gallery, London.

p. 27: detail, see p. 30.

p. 28: Rembrandt van Rijn, *The Jewish Bride*, c. 1666, oil on canvas, 121.5 x 166.5 cm, Rijksmuseum, Amsterdam.

p. 29: Gerard ter Borch, *Gallant Conversation*, c. 1654, oil on canvas, 70 x 60 cm, Rijksmuseum, Amsterdam.

p. 30: Jan Vermeer, *The Procuress*, 1656, oil on canvas, 143 x 130 cm, Staatliche Kunstsammlungen Gemäldegalerie Alte Meister, Dresden.

p. 31: Jan Vermeer, *Diana and Her Nymphs*, c. 1655–1656, oil on canvas, 97.8 x 104.6 cm, Royal Picture Gallery, Mauritshuis, The Hague.

p. 32: Jan Vermeer, *Saint Praxedes*, 1655, oil on canvas, 101.6 x 82.6 cm, The Barbara Piasecka Johnson Collection Foundation, Princeton.

p. 33: Jan Vermeer, *Christ in the House of Mary and Martha*, c. 1655, oil on canvas, 160 x 142 cm, National Gallery of Scotland, Edinburgh.

p. 34: Jan Vermeer, *Allegory of Faith*, c. 1671–1674, oil on canvas, 114.3 x 88.9 cm, The Metropolitan Museum of Art, New York, The Friedsam Collection, Legat Michael Friedsam, 1931.

p. 35: Jan Vermeer, *A Lady Writing*, c. 1665, oil on canvas, 45 x 39.9 cm, The National Gallery of Art, Washington, D.C., Gift of Harry Waldron.

p. 37: detail, see p. 40.

p. 38 top: detail, see p. 35.

p. 38 bottom: see p. 72.

p. 39 top: Pieter Jansz. Saenredam, *Interior View of St. Jacob's Church in Utrecht*, 1642, oil on panel, 55.2 x 43.4 cm, Alte Pinakothek, Munich.

p. 39 bottom: Vermeer's signatures, on the left dated 1662, on the right dated 1663 with Latinized spelling of the name.

p. 40: Jan Vermeer, *Art of Painting*, c. 1666/67, oil on canvas, 120 x 100 cm, Kunsthistorisches Museum, Vienna.

p. 41: detail, see p. 40.

p. 42: Claude Monet, *Farmhouse and Tulip Fields near Leiden*, 1886, oil on canvas, 59 x 73 cm, Sterling and Francine Clark Art Institute, Williamstown, Massachusetts.

p. 43: Georges Seurat, *Young Woman Powdering Herself*, 1889–1890, oil on canvas, 94.2 x 79.5 cm, Courtauld Institute Galleries, London.

p. 44 left: *Schematic Illustration of the Arrangement of Lenses of a Camera Obscura*, reproduction taken from *Apiaria Universae Philosophiae Mathematicae*, Bononia, 1642, Gernsheim Collection, University of Texas, Austin.

p. 44 right: Hans Vredeman de Vries, Graphic Number 24, taken from *Perspective*, Leiden 1604.

p. 45: Jan Vermeer, detail (see p. 72) with marked needle hole, X-ray, Rijksmuseum, Amsterdam.

p. 46: detail, see p. 48.

124

p. 47: detail, see p. 49.

p. 48: Jan Vermeer, *The Lacemaker*, c. 1669/70, oil on canvas on panel, 23.9 x 20.5 cm, Musée du Louvre, Paris.

p. 49: Jan Vermeer, *Girl with a Red Hat*, c. 1665, oil on panel, 22.8 x 18 cm, The National Gallery of Art, Washington, D.C., Andrew W. Mellon Collection.

p. 50: Jan Vermeer, *Woman Holding a Balance*, c. 1664, oil on canvas, 40.3 x 35.6 cm, National Gallery of Art, Washington, D.C., Widener Collection.

p. 51: Jan Vermeer, *Lady with a Water Pitcher*, c. 1664/65, oil on canvas, 45.7 x 40.6 cm, The Metropolitan Museum of Art, New York, gift of Henry G. Marquand, 1889, Marquand Collection.

p. 52: Jan Vermeer, *The Astronomer*, 1669, oil on canvas, 51.6 x 45.4 cm, Städelsches Kunstinstitut and Städtische Galerie, Frankfurt am Main.

p. 53: Jan Vermeer, *The Geographer*, 1668, oil on canvas, 51.5 x 45.5 cm, Musée du Louvre, Paris.

p. 54: detail, see p. 51

p. 55: detail, see p. 51

p. 56: Diego Velázquez, *Las Meninas*, 1656, oil on canvas, 310 x 276 cm, Museo del Prado, Madrid.

p. 57: Jan Vermeer, perspective illustration of *The Music Lesson* (see p. 61), with orthogonal and diagonal lines.

p. 58: Hendrick Cornellsz. Vroom, *View of Delft*, 1615, Stedelijk Museum Het Prinsenhof, Delft.

p. 59: Daniel Vosmaer, *View of Delft Through an Imaginary Loggia*, 1663, oil on canvas, 90.5 x 113 cm, Stedelijk Museum Het Prinsenhof, Delft.

p. 60: detail, see p. 61.

p. 61: Jan Vermeer, *The Music Lesson*, c. 1662–1664, oil on canvas, 74 x 64.5 cm, Her Majesty Queen Elizabeth II, The Royal Collection, Windsor Castle.

p. 62: Jan Vermeer, *The Little Street*, c. 1657/58, oil on canvas, 53.5 x 43.5 cm, Rijksmuseum, Amsterdam.

p. 63: detail, see p. 62

p. 64–65: Jan Vermeer, *View of Delft*, c. 1660/61, oil on canvas, 96.5 x 115.7 cm, Royal Picture Gallery, Mauritshuis, The Hague.

p. 66: detail, see p. 64–65.

p. 67: detail, see p. 64–65.

p. 70 left: Pieter de Hooch, *A Woman and Her Maid in a Courtyard*, c. 1660, oil on canvas, 73.5 x 60 cm, The National Gallery, London.

p. 70 right: Pieter de Hooch, *Dutch Family*, c. 1662, oil on canvas, 114 × 97 cm, Gemäldegalerie der Akademie der Bildenden Künste, Vienna.

p. 71: Abraham Rademaker, *Jesuits' Church in Delft*, c. 1720, pen and ink, Gemeentelijke Archiefdienst, Delft.

p. 72: Jan Vermeer, *The Milkmaid*, c. 1658–1660, oil on canvas, 45.4 x 40.6 cm, Rijksmuseum, Amsterdam.

p. 73: Willem van Aelst, *Still-Life with Fruit and Crystal Vase*, 1652, oil on canvas, 73 x 58 cm, Galerie Palatina, Palazzo Pitti, Florence.

p. 74: detail, see p. 80

p. 75: Jan Vermeer, *A Young Woman with a Flute*, 1665–1670, oil on panel, 20.3 x 17.8 cm, The National Gallery of Art, Washington, D.C., Widener Collection.

p. 76: reconstruction of Vermeer's *The Concert* by Philip Steadman. Photograph.

p. 77: Frans van Mieris the Elder, *The Artist's Studio*, c. 1655–1660, oil on panel, 64 x 47 cm, Gemäldegalerie Alte Meister, Dresden.

p. 78: Jan Vermeer, *A Lady Writing a Letter with Her Maid*, c. 1670, oil on canvas, 72.2 x 59.7 cm, The National Gallery of Ireland, Dublin.

p. 79: detail, see p. 78.

p. 80: Jan Vermeer, *Sleeping Girl*, c. 1657, oil on canvas, 87.6 x 76.5 cm, Metropolitan Museum of Art, New York, bequest of Benjamin Altman.

p. 81: Jan Vermeer, *Study of a Young Woman*, c. 1666/67, oil on canvas, 44.5 x 40 cm, The Metropolitan Museum of Art, New York, Gift of Mr. and Mrs. Charles Wrightsman, in memory of Theodore Rousseau, Jr., 1979.

p. 82: Jan Vermeer, *Mistress and Maid*, c. 1667/68, oil on canvas, 90.2 x 78.7 cm, The Frick Collection, New York.

p. 83: Jan Vermeer, *The Guitar Player*, c. 1670, oil on canvas, 53 x 46.3 cm, English Heritage as Trustees of the Iveagh Bequest, Kenwood.

p. 84: detail, see p. 85.

p. 85: Jan Vermeer, *The Girl with the Wine Glass*, c. 1659/60, oil on canvas, 77.5 x 66.7 cm, Herzog Anton Ulrich Museum, Braunschweig.

p. 86: Jan Vermeer, *The Concert*, c. 1665/66, oil on canvas, 72.5 x 64.7 cm, Isabella Stewart Gardner Museum, Boston, Massachusetts.

p. 87: Jan Vermeer, *Girl Interrupted at Her Music*, c. 1660/61, oil on canvas, 39.9 x 44.4 cm, The Frick Collection, New York.

p. 89: detail, see p. 85.

p. 90: *Cupid with Mirror*, engraving, emblematic illustration, c. 1600, 8.6 x 11.7 cm, undated

p. 91 top: detail, see p. 17.

p. 91 bottom: detail, see p. 50.

p. 92: Jan Vermeer, *The Love Letter*, c. 1669/70, oil on canvas, 44 x 38 cm, Rijksmuseum, Amsterdam.

p. 93: detail, see p. 17.

p. 94: detail, see p. 92.

p. 95: detail, see p. 101.

p. 96: Jan Vermeer, *Woman Playing a Lute*, c. 1664, oil on canvas, 51.4 x 45.7 cm, The Metropolitan Museum of Art, New York.

p. 97: Jan Vermeer, *Young Woman with a Pearl Necklace*, c. 1664, oil on canvas, 51.2 x 45.1 cm, Berlin State Museums, Gemäldegalerie, Berlin.

p. 98: Jan Vermeer, *Girl Reading a Letter at an Open Window*, c. 1657, oil on canvas, 83 x 64.5 cm, Staatliche Kunstsammlungen, Gemäldegalerie Alte Meister, Dresden.

If you want to know more

Books on Vermeer:

Walter Liedke, *Vermeer and the Delft School*, New York, New Haven, London / Metropolitan Museum of Art and Yale University Press, 2001.

Arthur K. Wheelock, Jr., Albert Blankert and Ben Boros, *Johannes Vermeer*, New Haven, London / Yale University Press, 1995.

Arthur K. Wheelock, Jr., *Vermeer: The Complete Works*, New York / Harry N. Abrams, 1997.

Arthur K. Wheelock, Jr., with contributions by Michiel C. Plomp, Danielle H.A.C. Lokin and Quint Gregory, *The Public and the Private in the Age of Vermeer*, London / Philip Wilson Publishers, 2000.

Albert Blankert, John Michael Montias and Gilles Aillaud, *Vermeer*, New York / Rizzoli, 1988.

Irene Netta, *Vermeer's World: An Artist and his Town*, Munich, Berlin, London, New York / Prestel, 2004.

John Montias, *Vermeer and his Milieu: A Web of Social History*, Princeton / Princeton University Press, 1991.

Edward A. Snow, *A Study of Vermeer*, Berkeley / University of California Press, 1994.

Anthony Bailey, *Vermeer: A View of Delft* / Holt Paperbacks, 2002.

Philip Steadman, *Vermeer's Camera: Uncovering the Truth behind the Masterpieces*, New York / Oxford University Press, 2002.

Epco Runia and Peter van der Ploeg, *Vermeer: In the Mauritshuis*, The Hague / Waanders Uitgevers, 2006

Robert D. Huerta, *Giants of Delft. Johannes Vermeer and the Natural Philosophers: The Parallel Search for Knowledge During the Age of Discovery*, Lewisburg, PA / Bucknell University Press, 2003.

Lawrence Gowing, *Vermeer*, Berkeley / University of California Press, 1997.

Ivan Gaskell, editor, *Vermeer Studies (Studies in the History of Art, Vol. 55)*, Washington, D.C. / National Gallery of Art, 1998.

John Nash, *Vermeer*, New York / Scala Publishers, 2002.

Bryan Jay Wolf, *Vermeer and the Invention of Seeing*, Chicago / University of Chicago Press, 2001.

Vermeer on the Internet:

Jonathan Janson, *Essential Vermeer* website, http://essentialvermeer.20m.com.

Books on Dutch painting of the 17th century:

Wayne Franits, *Dutch Seventeenth Century Genre Painting: Its Stylistic and Thematic Evolution*, New Haven, London / Yale University Press, 2004.

Mariet Westermann, *A Worldly Art: The Dutch Republic, 1505–1710*, New Haven, London / Yale University Press, 2005.

Peter C. Sutton, Peter C. Sutton, Lisa Vergara and Ann Jensen Adams, *Love Letters: Dutch Genre Paintings in the Age of Vermeer*, London / Frances Lincoln, 2006.

Imprint

The pictures in this book were graciously made available by
the museums and collections mentioned, or have been taken
from the Publisher's archive with exception of:
Ullstein Bild: pp. 26, 107, 108, 109, 120, 121, 122
Bridgeman: p. 106
AKG: pp. 90, S. 99, S. 116
Getty images: p. 115
Philip Steadman: p. 76

The Library of Congress Control Number: 2008929099

British Library Cataloguing-in-Publication Data: a catalogue
record for this book is available from the British Library.

The Deutsche Bibliothek holds a record of this publication in
the Deutsche Nationalbibliografie; detailed bibliographical
data can be found under: http://dnb.ddb.de

Prestel Verlag
Königinstrasse 9
80539 Munich
Tel. +49 (0) 89 24 29 08-300
Fax +49 (0) 89 24 29 08-335

Prestel Publishing Ltd.
4 Bloomsbury Place
London WC1A 2QA
Tel. +44 (0) 20 7323-5004
Fax +44 (0) 20 7636-8004

Prestel Publishing
900 Broadway. Suite 603
New York, N.Y. 10003
Tel. +1 (212) 995-2720
Fax +1 (212) 995-2733

www.prestel.com

Editorial direction by Claudia Stäuble
Copy-edited by Chris Murray
Series editorial and design concept by Sybille Engels,
engels zahm + partner
Cover, layout, and production by Wolfram Söll
Lithography by kaltnermedia, Bobingen
Printed and bound by Stürtz GmbH, Würzburg

Printed in Germany on acid-free paper

ISBN 978-3-7913-4062-3